IMAGES
of America

ITALIAN OAKLAND

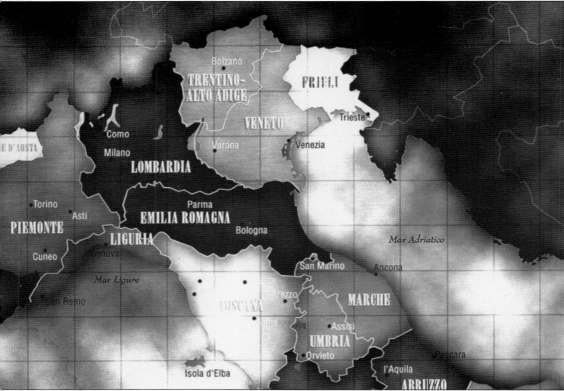

REGIONS OF ITALY. Since its unification in 1860, Italy has comprised 20 regions. Italians who came to California from the late 1800s through the early 1900s hailed predominantly from the northern regions of Piedmont, Liguria, Lombardy, and Tuscany, shown on this map. California appealed to them because of its familiar climate and terrain and because, in these early days, to them it truly was a "land of opportunity." (Courtesy of the Colombo Club.)

ON THE COVER: This *c.* 1900 scene typifies what Karen Garcia describes as "a good old Italian wedding." Although identities have been lost in the passage of time, the photograph is from her mother's side of the family and shows the bride and groom in white finery and celebrants toasting the couple with homemade wine, a staple of the day. The setting is north Oakland, possibly a picnic area. (Courtesy of Karen Garcia.)

IMAGES
of America

ITALIAN OAKLAND

*Dad...
Happiness is
being Italian! ☺
Love you —
& Terri
xoxo*

Rick Malaspina

ARCADIA
PUBLISHING

Published by Arcadia Publishing
Charleston, South Carolina

Printed in the United States of America

Library of Congress Control Number: 2010932073

For all general information, please contact Arcadia Publishing:
Telephone 843-853-2070
Fax 843-853-0044
E-mail sales@arcadiapublishing.com
For customer service and orders:
Toll-Free 1-888-313-2665

Visit us on the Internet at www.arcadiapublishing.com

For my son, Kit, and my parents,
Flora and Louie Malaspina: Gone but always with me.

CONTENTS

ACKNOWLEDGMENTS

Most of the images in this book came not from libraries or museums or historical organizations, but from ordinary people, people who generously contributed photographs and documents from their personal and family collections. They deserve the most recognition and gratitude. Visiting with them, hearing their stories, and sharing their memories made for a pleasurable and rewarding experience. The majority of images in these pages are derived from the collections of Louie Alberti, Manny and Marie Camara, Bev Chernoff, Cecile Cuttitta, Al and Deanna DeNurra, Karen Garcia, Elsie Giuntoli, and Angie Raniero. (Special thanks to Angie, and bless her heart, for never letting a visit pass without the pleasure of partaking in her homemade biscotti and bread sticks at her kitchen table. Just like the old days.)

Thanks, also, to the following for the information, insight, and photographs they provided: Colombo Club historian John Penna; archivist and "man for all seasons" at the Fratellanza Club, Gianfranco Sciacero; local historian and raconteur Ray Raineri (when it comes to Oakland Italian American history and lore, all roads lead to Ray); Jess Giambroni, a young man with an appreciation of the past; and Ray "Remo" Mellana, a loyal and prolific correspondent and a true "Temescalian." Helpful in other ways were Ed Basso, professor Teri Ann Bengiveno, Elma and Leroy Casale, Dave Newhouse, Jeff Norman, professor Laura E. Ruberto, and Richard Vannucci. For research assistance, thanks to Allan Fisher of the Western Railway Museum.

Loving and everlasting gratitude—for much more than her help here—to Leigh Trivette-Malaspina. Her support, advice, and patience, together with her expert technical assistance, were vital to the completion of this project. (She is not even of Italian descent, yet she appreciates and tolerates us all the same. Amazing.)

Finally a nod to the Oakland and East Bay Italian American community, particularly the guys and gals of the Colombo, Fratellanza, and Ligure clubs, and members of other Italian American cultural and historical associations. You are keeping the legacy alive. And whether you know it or not, you are a source of inspiration and sustenance. *Grazie a tutti!*

INTRODUCTION

Sempre avanti. In Italian, it means, "Always move forward." The phrase was heard and uttered often by Italians in old Oakland, sometimes paired with the words *sensa paura,* or "without fear." *Sempre avanti, sensa paura.* More than a saying or greeting, it was a call of mutual encouragement, support, and camaraderie from one friend or family member or fellow newcomer to the United States to another: *Onward, have courage, be strong, never fear, press on.* In a sense, the phrase symbolizes the Italian American immigrant experience itself and certainly captures the indomitable spirit of early immigrants. They left their homeland and their loved ones, typically with little or no belongings, and traveled by sea to an unknown land with a strange language and new customs. They often faced hardship and adversity, but through hard work, determination, and perseverance they built new lives and contributed in various ways to the growth and betterment of their communities and their adopted country.

The greatest influx of Italians to the United States took place between 1880 and 1920, when more than four million Italians came to a country whose name they could pronounce because of its Italian origin but knew little about—except that it offered opportunity and prosperity. They came largely from southern Italy, mainly the regions of Sicily and Calabria, escaping poverty, overpopulation, unemployment, and the effects of soil erosion, natural disasters, and disease that beset both people and crops. Most of these immigrants were single men in their teens, twenties, and thirties—peasants, mostly—and unmarried men or men who left their wives behind and called for them later, after finding housing and work. Most of these immigrants put down roots in the urban centers of the East Coast, which accounts for the Italian neighborhoods and concentrations of residents of Italian descent existing there today.

Other Italian immigrants, however, were more adventurous than their countrymen. They went West. After the weeks-long transatlantic voyage from Italy, they traveled a long distance again, this time by train, to a newer, more expansive land of opportunity called California. It was a place where the climate, geography, and means of livelihood more closely resembled those of the parts of Italy they had left behind. These hardy pioneers hailed predominantly from northern Italy, the regions of Tuscany, Liguria, Lombardy, and Piedmont. They left Italy for many of the same reasons as other immigrants, but for these northern Italians a different sort of American experience beckoned—and their move west resulted in a legacy of ingenuity, creativity, and entrepreneurship that helped shape the Golden State and flourishes to this day.

Two local documentary exhibits give particular perspective to the history of Italian Americans in California. One, titled *In Cerca di Una Nuova Vita* ("In Search of a New Life"), was produced by San Francisco's Museo ItaloAmericano (museoitaloamericano.org) and presented there in 2009–2010. The other is an online exhibit, Italian Americans in California (bancroft.berkeley.edu/collections/italianamericans), crafted by the Bancroft Library at the University of California at Berkeley with funding from the National Italian American Foundation.

Taken together, these exhibits frame the movement of Italians to California in three stages, or waves. The first and largest wave, consistent with the general pattern of Italian immigration to the United States, spanned the period between 1850 and 1924. Although mostly poor and unskilled, these immigrants arrived early in the state's development and were able to take advantage of its burgeoning economy. They found work in the agriculture, fishing, winemaking, mining, railroad, logging, construction, food processing, and manufacturing industries. They also struck out on their own as laborers, merchants, and craftsmen. Some, or their offspring, began businesses and companies in California that would grow to worldwide prominence.

The second wave of Italian immigration to California took place after 1924 and extended until after World War II. In contrast to the Italians who preceded them, the immigrants in this second wave were from Italy's middle class, affluent, and generally older. They had endured Italy's political, social, and economic turmoil before and after the war and the devastating aftermath of the war. Like their predecessors, they left Italy in search of a new beginning in the United States.

A more recent, though perhaps less apparent, wave of Italian immigration began in the 1970s. It brought to California a breed of immigrants from every part of Italy, lured by a new era of enterprise and innovation in the state. They were entrepreneurs, scholars, scientists and engineers, artists and professionals, and they made significant contributions in areas such as high technology, agribusiness, biotechnology, research, and higher education.

Against this backdrop stands Oakland's Italian American community. From its beginning in the late 1800s to the early 1900s, it grew to be a center of activity, advancement, and assimilation for thousands of immigrants and their families. Early residents, part of the first wave of Italian immigration, settled in Oakland and other cities and towns on the east side of San Francisco Bay, stretching from Martinez to San Jose. They came from the larger, more established, and more prominent city of San Francisco after the earthquake and fire of 1906 destroyed much of the Italian district of North Beach and other parts of the city or to escape labor union resentment in San Francisco against cheap, unskilled labor. They came from the more crowded and urban centers of the East Coast, where many immigrants remained after leaving Italy. They came directly from Italy, encouraged by friends and family members who had already made their way to California or enticed by California's natural appeal at the dawn of the 20th century.

By the 1930s, Oakland had one of the largest Italian American populations in California. And within Oakland, the place to live for Italians—or the place to move up to for many—was a bustling section of north Oakland known as the Temescal district. It had everything Italian residents needed to feel at home, and then some. The 1950s and 1960s, however, brought an end to Temescal, at least as old-timers knew it. Like other Italian American enclaves in California and elsewhere, the old neighborhood, both physically and culturally, was giving way to factors such as urban development and suburban sprawl, changing demographics, and increasing independence and affluence among young people as they started families and sought housing of their own. In short, the need and desire to maintain a close-knit, ethnic community was dissipating, an experience common to other ethnic populations, an American experience.

This book highlights the history and character, the feeling and flavor, of a special time and place. It is a time and place that exists in the hearts and minds of those who were there and still remember and that lives on, at least in spirit, for those who have the joy—and the duty—of upholding Oakland's Italian American heritage.

Sempre avanti.

One

NEW LIFE IN A NEW LAND

Italian immigrants ventured to the United States in the late 1800s and early 1900s the only way they could—the hard way. The voyage by sea could take up to 30 days. They traveled in steerage, where conditions were cramped and uncomfortable and meals typically consisted of shared soup or stew. They had few belongings other than the clothes on their backs and what they could carry in a suitcase or a sack. And once in this place called America, they spoke no English, had no work readily at hand, and often knew no one.

For Italians who went West—all the way to California, for example—the experience was more arduous. It meant another 3,000 miles and five days or more of dusty, bone-rattling railroad travel, with more uncertainty along the way.

Marietta Poggi was a young woman when she left her village of Varzi in the hills between Milan and Genoa in Italy's Lombardy region in the early 1900s. The author's maternal grandmother, she traveled by ship from Genoa to New York and then by train to California. She would tell her young grandson of her journey, saying that relatives in New York—probably taken by tall tales of the Wild West—warned her not to disembark from the train when it stopped in Santa Fe, New Mexico. There were Native Americans, she was told, and they could be dangerous.

For Marietta and other immigrants, when they finally settled in their adopted homeland, it was time to find housing, get work, make friends, start families, and become part of a community. It was time to build a new life in a new land.

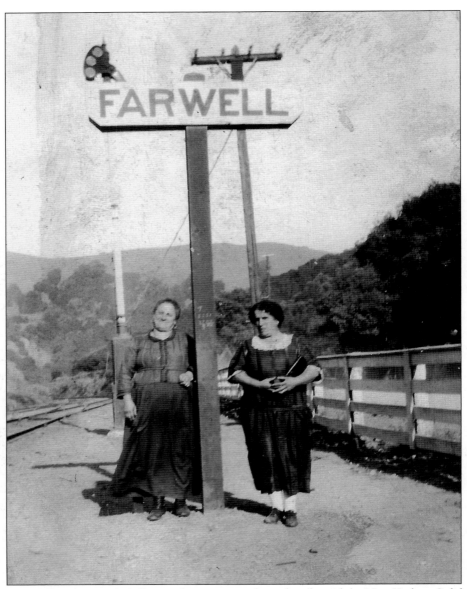

CALIFORNIA BOUND, C. 1910. Pictured at a stop on the railroad trip from New York to California are the author's grandmother Marietta Poggi (right) and an unidentified traveling companion. Marietta came from the village of Varzi in the hills of northern Italy—first to New York, then to California. The terminus of the transcontinental railroad route was Oakland; known as the Overland Route, it brought thousands of Italians to California and other western states during the first wave of Italian immigration. This photograph, from the author's family collection, was taken during a stop in what mostly likely was Farwell, Nebraska. After arriving in Oakland, Marietta would cross San Francisco Bay by ferry—there were no bridges on the bay then—and settle in the small community of Colma on the southern outskirts of San Francisco. She and husband Ernesto Tambussi, also from the Varzi area, had a vegetable farm, a typical means of livelihood for Italian immigrants in parts of the San Francisco Bay Area before fertile farmland gave way to urban growth and suburban development. (Author's collection.)

HOMELAND VILLAGES. Early Italian immigrants to Oakland came largely from rural villages in northern Italy such as Varzi (above) in the Lombardy region and Sant' Albano (below) in the Piedmont region. Although relatively recent, these postcard images show the landscape much as it was when the bulk of Italians left their homeland in the late 1880s and early 1900s. People lived off the land in simple stone structures in and around a main village. As hard times gripped Italy and families struggled to survive, many left in search of a better life, leaving parents, siblings, and other loved ones. It was common for immigrants, after gaining a level of stability and income, to send money and goods to relatives in the old country to soften the effects of poverty and the ravages of war. (Both author's collection.)

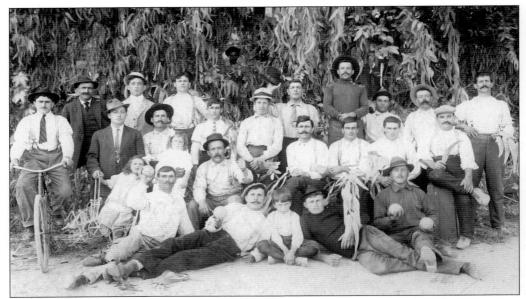

QUARRY WORKERS, C. 1900. Many Italian immigrant men found work at the Bilger Quarry in what is now the Rockridge area of north Oakland. These unidentified workers—judging from their dress, the bocce balls in one fellow's hands, and the family members with them—seem to be enjoying a picnic at or near the quarry. (Courtesy of the Colombo Club.)

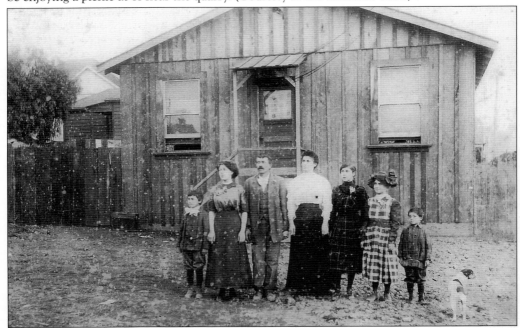

LAVAZZI FAMILY, 1906. Soon after Michele and Luisa Lavazzi (center) emigrated from Italy's Piedmont region, they were photographed here with their five children. Their home was on Thirty-ninth Street, near Grove Street, in north Oakland. Michele was a stonemason and most probably used material from the Bilger Quarry, which accounted for many of the buildings and paving projects in Oakland and the East Bay. (Courtesy of Karen Garcia.)

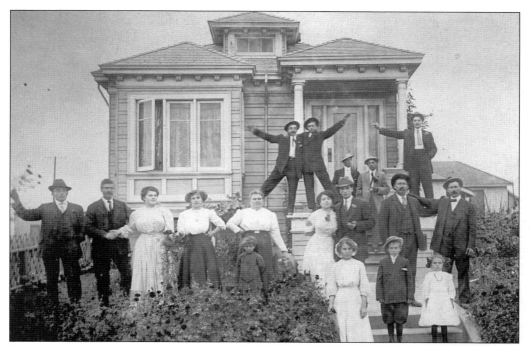

BOARDINGHOUSES, C. 1910. It was common for Italian immigrant men, as they got on their feet in Oakland, to live in boardinghouses, where they received clean quarters and square meals. Italian families typically operated these houses as a means of earning income for themselves, and the men mostly were quarry workers, garbage collectors, and laborers. Later they would start families and have homes of their own. In the photograph above, proprietors and tenants are celebrating a happy moment. Below, scavengers in work garb pose outside their west Oakland boardinghouse. (Above, courtesy of Beverly Chernoff; below, courtesy of Louie Alberti.)

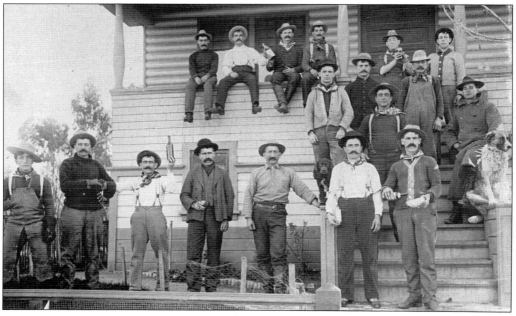

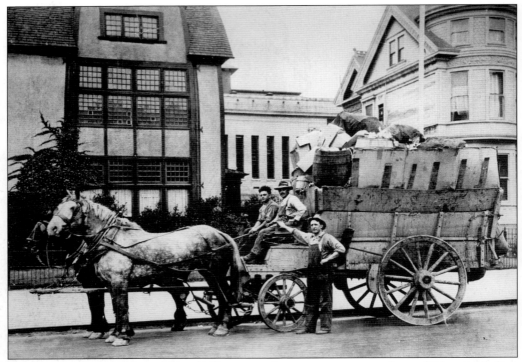

DOWNTOWN SCAVENGERS, 1920s. Collecting garbage was a common form of labor for Italian immigrants, and before the introduction of motorized vehicles, they used horse-drawn carts to haul garbage. Here mustachioed Giuliano Moglia, known as "Gian," is with two unidentified coworkers in downtown Oakland. In the far background is the Alameda County Courthouse. Gian's niece Yoli was a bookkeeper for the Oakland Scavenger Company for 39 years. (Courtesy of Yoli Moglia.)

EAST OAKLAND SCAVENGER, C. 1920. As his children play in the foreground, Steve Perata goes about his garbage collection rounds in east Oakland. He is carrying a full load by horse-drawn cart and would have worked from sunrise to sundown, hauling refuse by hand. East Oakland streets were mostly level, but for scavengers who worked the Oakland hills, the work was even more grueling. (Courtesy of John Tandi.)

FIELD WORKERS, c. 1920. Many Italian immigrants worked on vegetable and fruit farms in the Bay Area. It was a type of work they knew well, and many farms operated by Italian immigrants, such as those on Bay Farm Island in Alameda, a community bordering Oakland, grew to become major businesses. These unidentified field hands are knee-deep in kale and chard, probably in west Oakland. (Courtesy of Al and Deanna DeNurra.)

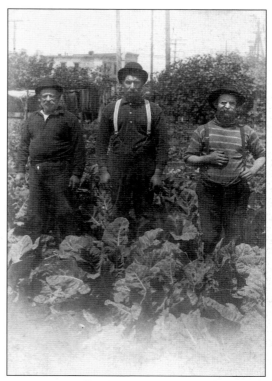

GROCERY DELIVERY, c. 1905. Once picked, vegetables, along with other goods, were peddled and delivered by horse-drawn cart, another form of employment for Italian immigrants. In this photograph, Caesar Sobrero (left) and partner Andrew Giambroni prepare to head out in their delivery buggy in Oakland's Dimond district. The Dimond Grocery is in the background. They would travel many miles daily through the east Oakland foothills. (Courtesy of the *Oakland Tribune*.)

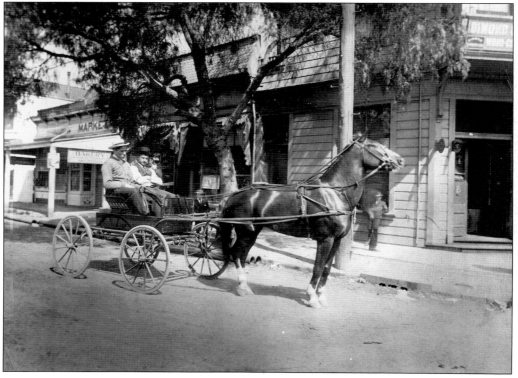

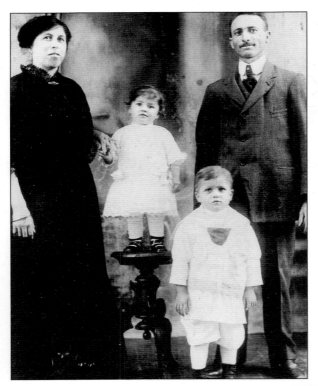

PUPPIONE FAMILY, 1908. Shown in this portrait soon after the family emigrated from Italy are Pietro and Lucia Puppione with daughter Rina, perched atop a lamp table, and son Valentino. They came from a village near Torino in the Piedmont region of Italy and lived on Fifty-first Street in Oakland. Valentino would become one of the founders of Oakland's Colombo Club, a large Italian American social club that remains active today. (Courtesy of Rich Puppione.)

DAPPER DUO, c. 1930. Brothers Antonio "Tony" and Vito "Willy" Calamonaci strike a proud pose in this portrait, which was printed in postcard form for mailing to friends and relatives in Italy. The brothers, who came from Sicily, raised families in north Oakland and lived there the rest of their lives. They were pressers in the garment industry, which most likely explains their natty attire. (Courtesy of the Cuttitta family.)

ALETTO WEDDING, 1921. Weddings were a major event in the lives of Italian immigrants. Not only did they mark the start of a new life, but also a new life in a new land. Here Fiorentino Aletto (with hat), a native of Italy's Piedmont region, escorts his bride Rosalina, from Lucca in the Tuscany region of Italy, on their wedding day in north Oakland. (Courtesy of Angie Rainero.)

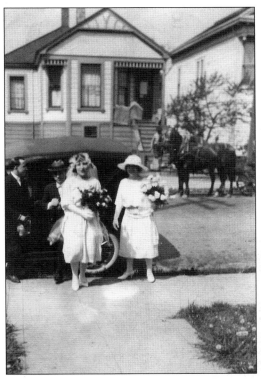

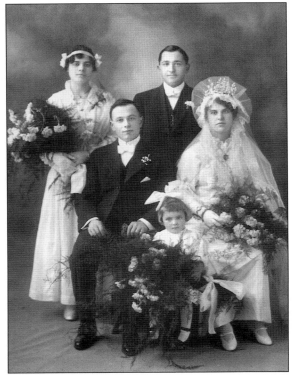

MARCHISIO WEDDING, 1915. Dressed in full formal attire in this vintage wedding portrait are Peter and Victoria Marchisio with unidentified attendants and flower girl Alice Degiorgis. The bride and groom, who were married and lived in Oakland, came from Alessandria, a province in the Lombardy region of northern Italy. (Courtesy of Beverly Chernoff.)

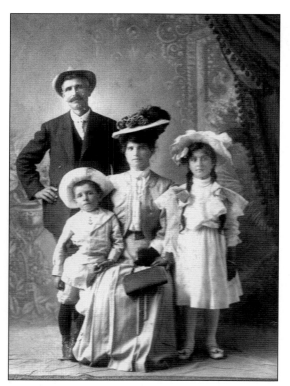

PROMINENT FAMILY, C. 1890. This is believed to be a portrait of the Orio family, probably soon after their arrival in Oakland. They were among the early residents of north Oakland, which grew to be the hub of Oakland's Italian American community. Patriarch Cesare Orio was a successful merchant and business leader. (Courtesy of Karen Garcia.)

FIRST GENERATION AMERICANS, 1920s. Angelically pictured here are the children of Sicilian immigrants Giuseppe and Lucia Cuttitta, who came to Oakland from New York City in 1924. From left to right are (seated) Peter; (standing) Rose, Salvatore, and Marie. All lived and worked their adult lives in Oakland. (Courtesy of the Cuttitta family.)

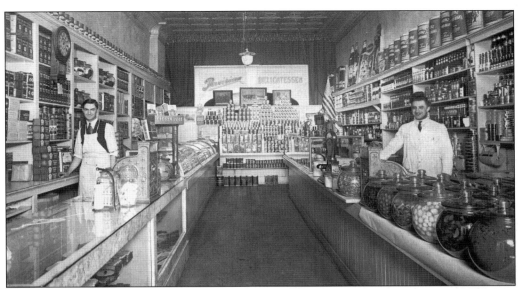

BIRTH OF A FAMILY BUSINESS, 1919. Only three years after he emigrated from northern Italy at the age of 17, Annabile Giovanni Ferrari (right) opened his first grocery store. It was in San Jose, with others to follow in Berkeley and Oakland. Today A. G. Ferrari Foods, under the leadership of grandson Paul Ferrari, offers specialty goods at 13 stores in Oakland and the Bay Area. (Courtesy of Paul Ferrari.)

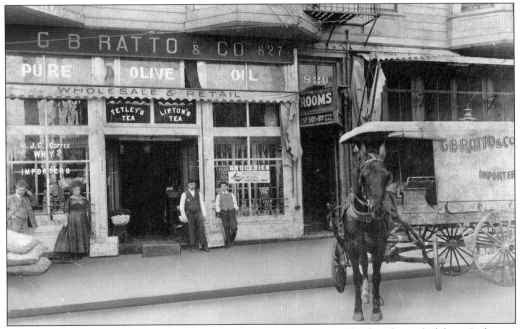

EARLY ENTREPRENEURSHIP, 1897. Giovanni Battista Ratto was 13 when he sailed from Italy as a cabin boy on a schooner to Buenos Aires. After making his way to Northern California, he worked in the produce business and started this market, specializing in imported foods in downtown Oakland. He is shown at the far left of this photograph. His descendants operate the G. B. Ratto Market and Deli. (Courtesy of Elena Durante-Voiron.)

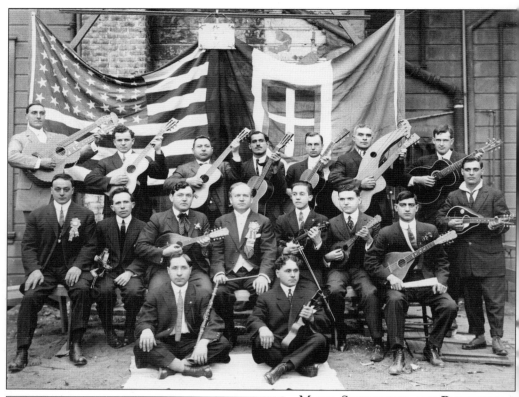

MUSIC, SOCIALIZING, AND PATRIOTISM, c. 1920. Notable in this image of the L'Italia Social Mandolin Club of Oakland is the backdrop—a U.S. flag and what appears to be a flag of Italy's Piedmont region, home region of many Italian immigrants to Oakland. It was common for Italians during this period to form bands, typically composed of men, within neighborhoods and fraternal organizations. (Courtesy of the Museo ItaloAmericano.)

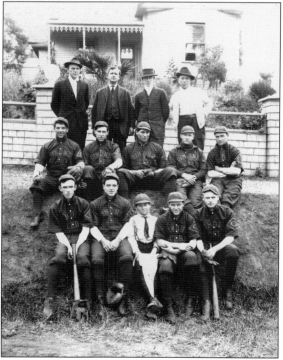

PLAY BALL, c. 1915. This photograph of the Dimond Grocery baseball team illustrates how early Italian residents of Oakland took to a sport that was new to them, and how they joined with fellow residents in playing the game. Only a few of these men are Italian; they include Andrew Giambroni (third row, second from left), who owned the grocery and sponsored the team. (Courtesy of Jess Giambroni.)

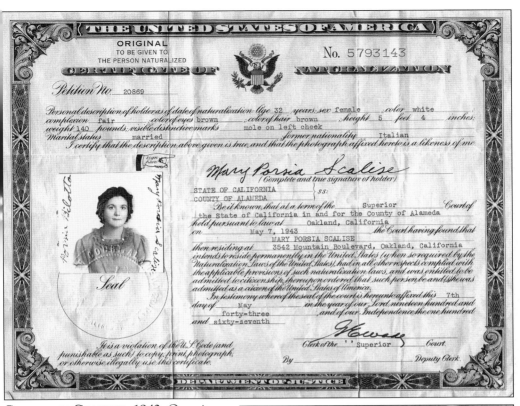

CITIZENSHIP GRANTED, 1943. Once in the United States, Italian immigrants sought and were proud to achieve citizenship. This is the original naturalization certificate of Mary Parsia Scalise. She emigrated from the Calabria region in 1933, coming first to Weed, a farming and lumbering area of Northern California, then to Oakland, where she and her husband, Joseph, a butcher and market owner, raised a family. (Courtesy of Joe Scalise Jr.)

ANOTHER NEW CITIZEN, c. 1910. Fiorentino Aletto was 16 when he immigrated to the United States from a village in Italy's Piedmont region, then to Oakland. He would serve in World War I, then return to Oakland, where he was married, raised two daughters, worked as a machinist, and became a well-known member of Oakland's Italian American community. (Courtesy of Angie Rainero.)

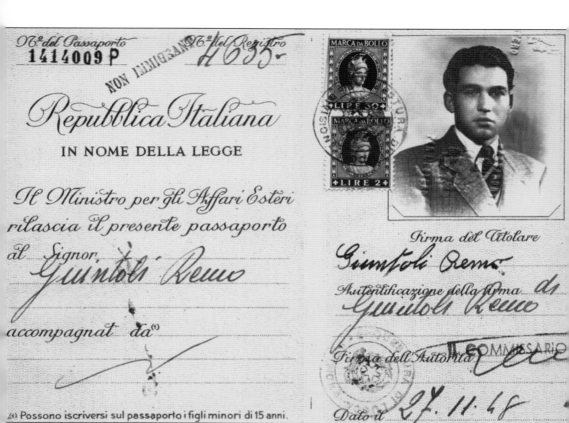

PASSPORT TO AMERICA, 1948. Bearing this passport, Silvano Giuntoli boarded a cargo ship in Genoa bound for a new life in the United States. He made his way to Oakland, where he married, raised a family, and lived until his death. His widow, Elsie, has lovingly preserved this passport and other memorabilia, including a poem Silvano composed during his voyage. He wrote it in Italian and titled it "For My Parents." It reads in part, "I said good-bye to relatives and friends, with great sorrow for my family. I left my mother sitting beside the fireplace; her heart filled with sadness." In the poem, Silvano also described bidding farewell to his father as he boarded the ship: "I said to him, 'Father, farewell and courage . . . maybe the large sea divides us, but it cannot separate our hearts.' Without speaking, he drew me to his heart." (Courtesy of Elsie Giuntoli.)

Two

FAMILY, HOME,

AND COMMUNITY

Without realizing it, Italian Americans may have coined the term "family values" before it made its way into the American lexicon. Hard work, togetherness, discipline, honesty, respect for elders, religious faith, frugality, self-sufficiency . . . these were some of the guiding principles of life for Italian Americans in Oakland and elsewhere. Early immigrants brought these values with them to the United States and passed them on to their children and grandchildren, the second and third generation of Italian Americans, who came of age in the 1930s, 1940s, and 1950s.

Among the cherished memories of growing up Italian American are sharing the bounty of family vegetable gardens (Why buy lettuce and tomatoes when they could be grown?); attending parochial school with nuns in full habit as teachers; spending long hours in church and partaking in the Catholic sacraments of First Holy Communion and Confirmation; and going to big weddings, picnics, and other social gatherings with dancing and lots of good food—including ravioli, gnocchi, or lasagna along with the Thanksgiving turkey.

A particular feature of Italian American family life was Sunday dinner at home. An anecdote popular among Italian Americans who "remember when" describes a typical scene this way:

Sunday dinner started at 1:00 p.m. Everyday plates were used; it didn't matter if they didn't match—they were clean, what more do you want? Bottles of wine, preferably homemade, and 7-Up were on the table. First course, antipasto . . . change plates; next, roasted meat, roasted potatoes, and overcooked vegetables . . . change plates; after that, green salad, but with oil-and-vinegar dressing only. . . change plates. Then fruit and nuts (in the shell) on paper plates because you ran out of other ones, with strong coffee and cookies. After dinner, the kids played, the men slept, the women cleaned up and talked. If you were a kid and you did something wrong, your mother or *nonna* yelled at you in half-Italian, half-English. If you kept it up, women who never threw a baseball or football in their lives nailed you with a shoe thrown from the kitchen before you know what hit you.

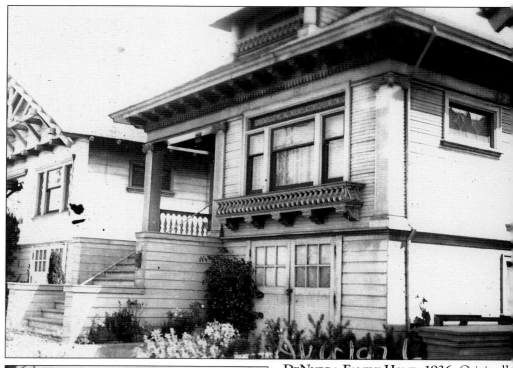

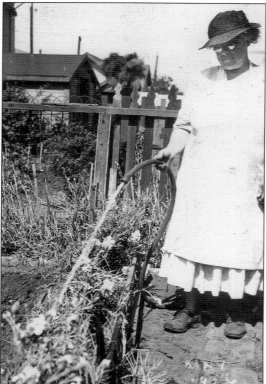

DeNurra Family Home, 1936. Originally from Sardinia, an island region of Italy off the western Mediterranean coast, the DeNurra family was well situated in this home on Fortieth Street in north Oakland at the time of this photograph. It is typical of the construction of the day and similar to many homes in Oakland where Italian families lived for generations. (Courtesy of Al and Deanna DeNurra.)

Tending Flowers, 1926. Maria Ferro DeNurra, in sun hat and apron, waters her carnations in the flower garden of the family's home (shown above). Maintaining gardens, for both the beauty and bounty they provided, was an important part of life for Italian families. (Courtesy of Al and Deanna DeNurra.)

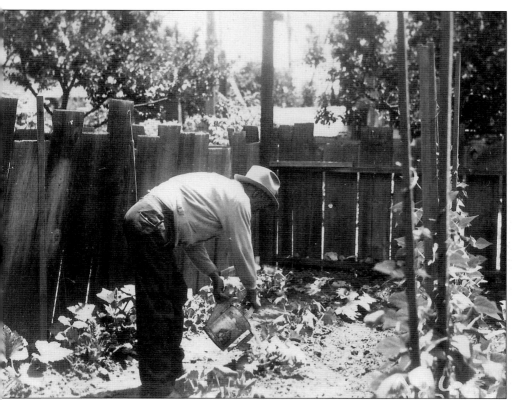

VEGETABLE GARDEN, 1936. These scenes of the DeNurra vegetable garden show both the hard work required to maintain a healthy crop and the delight in seeing the result. In the photograph above, family member Peter Ferro, in his felt fedora, carefully waters plants; at right, his daughter Mary DeNurra Boegel smiles amid tall rows of beans ready for picking. Oakland, with its Mediterranean climate, was ideal for cultivating a variety of vegetables, herbs, and fruit in home gardens, and even though the setting was urban, Italians made good use of every piece of available ground, including front yards. Their gardens brimmed with tomatoes, beans, peas, zucchini, peppers, parsley, basil, oregano, chard, lettuces, and a variety of fruit. (Both courtesy of Al and Deanna DeNurra.)

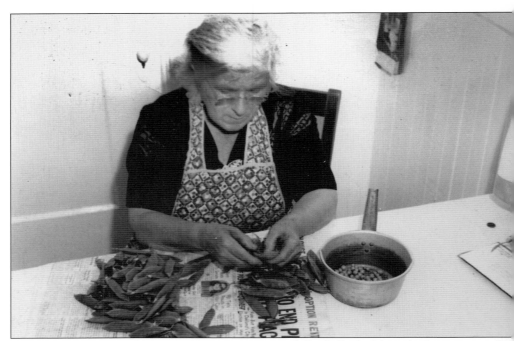

SHELLING PEAS, C. 1945. Maria Ferro DeNurra carefully shells freshly picked peas, or *piselli* i Italian, from the family garden, working at a kitchen table on sheets of newspaper. The shelled pe go right into the pot for boiling and then to the family dinner table. Maria's son Joseph, an amateu photographer, took this treasured family image. (Courtesy of Al and Deanna DeNurra.)

FOOD FOR THE FAMILY, 1920s. For Italians, gardening was more than a hobby—it was a way t provide fresh, nutritious food for the family table. This well-tended garden, proudly shown in th photograph from an Oakland family album, is lush with string beans ready to grow up peake stakes. (Courtesy of Al and Deanna DeNurra.)

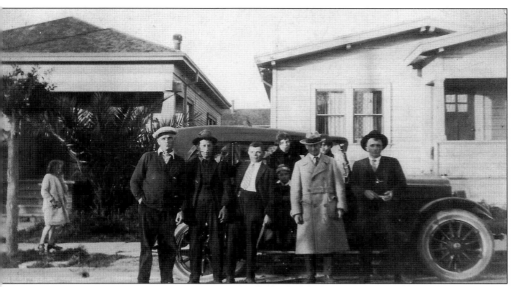

FRIENDS OF THE FAMILY, 1920s. These unidentified Lavazzi family friends stand beside what appears to be a new automobile outside a north Oakland residence, possibly the Lavazzi home since this photograph came from the family collection. The hats and coats indicate it was a cold day, although this was also part of manly attire at the time. (Courtesy of Karen Garcia.)

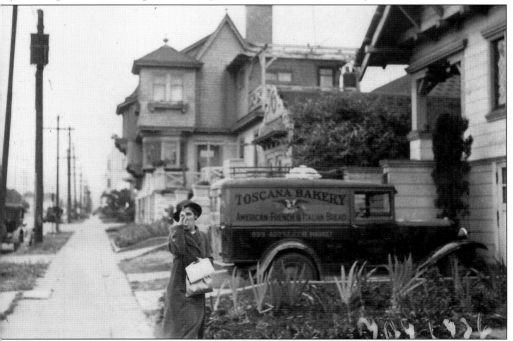

POKING FUN, 1937. Joseph DeNurra captured his sister, Elsie, in this whimsical scene outside the family home on Fortieth Street in north Oakland. Particularly notable is the Toscana Bakery delivery van with its orate lettering. The Oakland bakery, representative of the kinds of business begun by Italian immigrants, sold Italian-style bread and other baked goods and employed many of Oakland's Italian residents. (Courtesy of Al and Deanna DeNurra.)

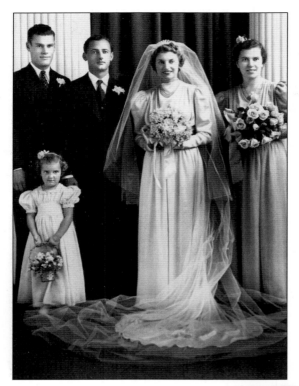

STROBINO WEDDING, 1939. This graceful bride in her elegant gown is Alice Degiorgis Strobino, shown in a previous photograph from 1915 as the flower girl in the wedding of Emma Marchisio's parents. Emma is the bridesmaid here. To the left of groom Perry Strobino is best man Aido Stura. All lived in Oakland. (Courtesy of Beverly Chernoff.)

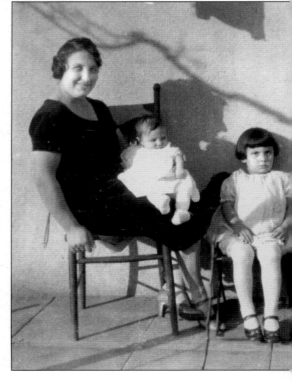

MOTHER AND DAUGHTERS, 1927. Rosalina Aletto, shown in a previous photograph on her wedding day, had two daughters, Angie, at right, and Hazel. Rosalina came to Oakland from the Tuscany region of Italy when she was 19. Rosalina, her husband, Fiorentino, and the girls lived in north Oakland's Italian American neighborhood. (Courtesy of Angie Rainero.)

COLUMBUS DAY QUEEN, 1936. Dating to the early years of Oakland's Italian community, a major cultural event was the celebration of Columbus Day. This photograph shows young Julia Persoglio, a member of a prominent Oakland Italian family, with her ceremonial gown, banner, and sword after being crowned as Queen Victoria. Young women competed for the honor. (Courtesy of Karen Garcia.)

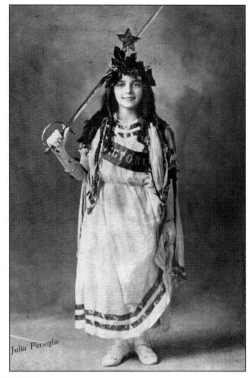

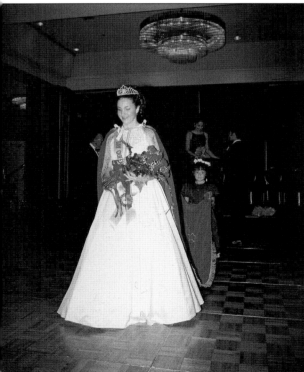

COLUMBUS DAY QUEEN, 2000. The tradition of selecting a Columbus Day queen continues today in Oakland's Italian American community, although with less fanfare and fewer ancillary events than in past years. In this contemporary photograph, Christina Barassi, followed by a young attendant, begins her reign as Columbus Day queen. She represented the Fratellanza Club, one of Oakland's few remaining Italian American social organizations. (Courtesy of the Fratellanza Club archives.)

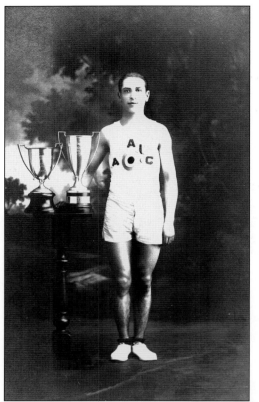

AT WORK AND PLAY, 1900s. These two views of Henry Persoglio represent different aspects of life in Oakland's early Italian community. In the 1923 studio portrait at left, Henry poses proudly either before or after a major foot race sponsored by Oakland's Alfieri Athletic Club. It pitted members of Italian American clubs in Oakland against two rival clubs from San Francisco. They ran, it is believed, from north Oakland, the heart of the Italian American community, to Lake Merritt in downtown Oakland and back, a distance of roughly 8 to 10 miles. The other photograph shows Henry some years earlier on the unpaved streets of Oakland when he worked delivering bakery goods to homes and businesses by horse-drawn cart. (Both courtesy of Karen Garcia.)

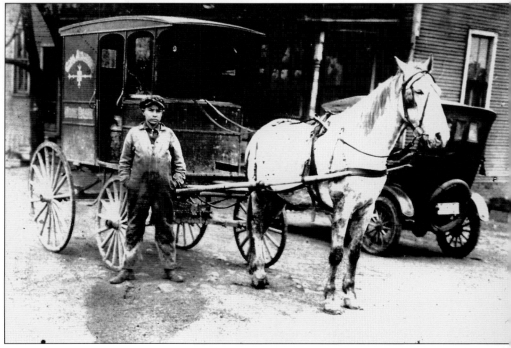

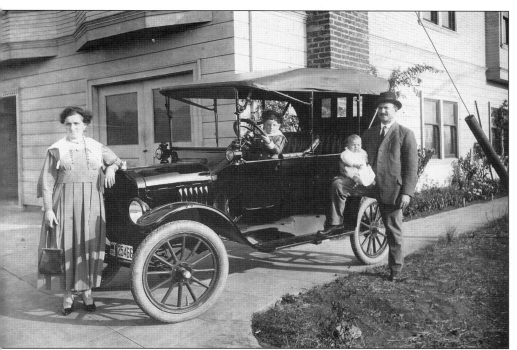

DEVALLE FAMILY, 1917. Giuseppe Devalle proudly displays the family's new automobile in front of the family's east Oakland home. With him are his wife, Filomena, and their sons, Aldo, at the wheel, and Eddie. Devalle came to Oakland from the Lucca area of Italy's Tuscany region. He built this home and three others in Oakland. (Courtesy of Beverly Chernoff.)

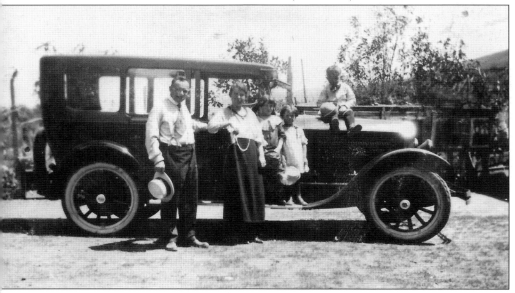

MARCHISIO FAMILY, 1920s. Peter and Victoria Marchisio pose beside the family's new automobile with their children, Norma (left), Emma, and Alex. The Marchisios' wedding portrait appears in a previous chapter. A few years later, like many immigrants to Oakland, they had started a family and begun to acquire the conveniences of American life. (Courtesy of Beverly Chernoff.)

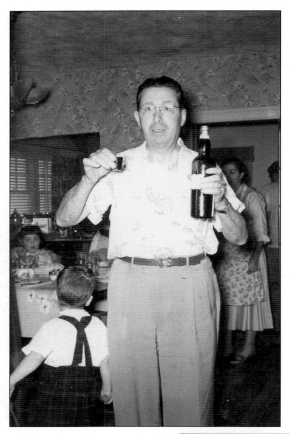

SALUTÉ FROM JOE CUTTITTA, 1950S.
Giuseppe "Joe" Cuttitta immigrated to the United States from Sicily in his teens. He lived with his family on Forty-eighth Street in north Oakland and had a barbershop on Franklin Street in downtown Oakland. His wife, Lucia, was a seamstress. Their granddaughter, Cecile, explains that Joe made wine in the cellar of the family home. (Courtesy of the Cuttitta family.)

ANNIVERSARY CELEBRATION, 1957. Giuseppe "Joe" and Lucia "Lucy" Cuttitta celebrate their 40th wedding anniversary as grandson Chris looks on. Their home on Forty-eighth Street in north Oakland was a gathering spot for the extended Cuttitta family and many Sicilian immigrant friends. Joe was a barber in downtown Oakland and Lucy was a seamstress known for her cooking skill. (Courtesy of the Cuttitta family.)

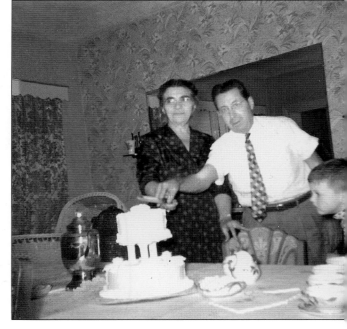

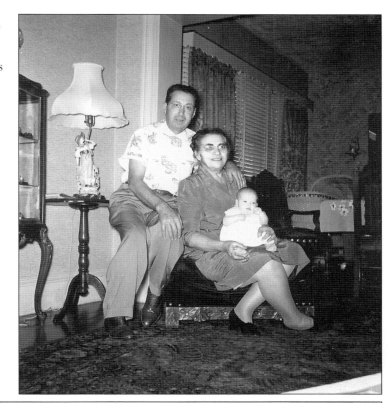

PROUD GRANDPARENTS, 1955. This living room scene was typical of Italian American homes in Oakland. Posing with granddaughter Cecile are Giuseppe "Joe" and Lucia "Lucy" Cuttitta at their home on Forty-eighth Street in the heart of Oakland's Italian American community. Of note is the ornate Capodimonte lamp: "Every Italian I knew must have had one just like it," Cecile says. (Courtesy of the Cuttitta family.)

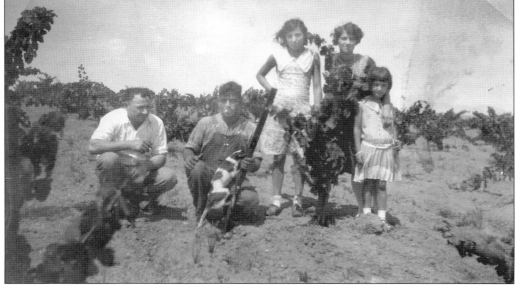

LENDING A HAND, C. 1927. On a friend's grape farm in Petaluma are, from left to right, John Posca; an unidentified friend; Virginia Fornaca; her mother, Fermina; and cousin Annnabelle. Although it took a while to get there from their homes in Oakland, in the spirit of Italian American fellowship, Posca and others would travel to the Marin County farm to help work the land. (Courtesy of Karen Garcia.)

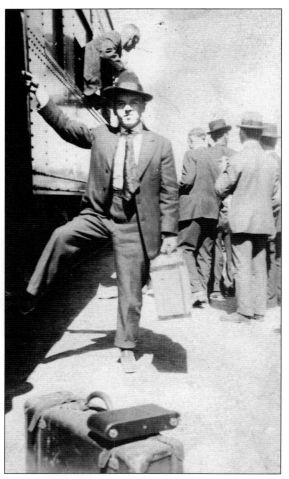

VISITING ITALY, 1932. Like many Italian immigrants, the Alettos of north Oakland, after establishing themselves in the United States, traveled back to Italy to visit family and friends. Fiorentino is seen here boarding the train in Oakland for the long trip to New York; the family would then travel by sea to Italy. The other photograph, taken in Fiorentino's ancestral village of Montemagno in the Piedmont region, shows Rosalina and Fiorentino (far left) with their daughters Hazel and Angie in the foreground (right), amid family members. "When we left on the train," Angie remembers, "our whole block from our neighborhood in Oakland came to see us off." To help with hard times in Italy, Italian Americans would also send money, clothing, and other goods to family members in the old country. (Both courtesy of Angie Rainero.)

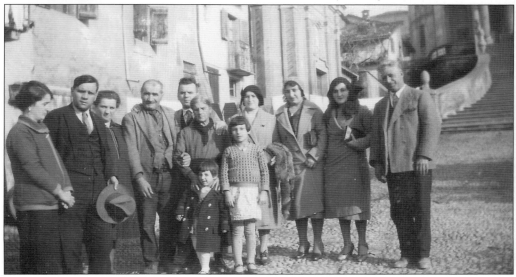

FIRST HOLY COMMUNION, 1964. Growing up Italian, for most Italians in Oakland, meant being Catholic, going to church, and partaking in the sacraments. This was First Communion day for Cecile Cuttitta, about age 10, whose grandparents were Italian immigrants. She is with Sister Mary Stephen of St. Leo's school and church in north Oakland, where three generations of the Cuttitta family lived for many years. (Courtesy of the Cuttitta family.)

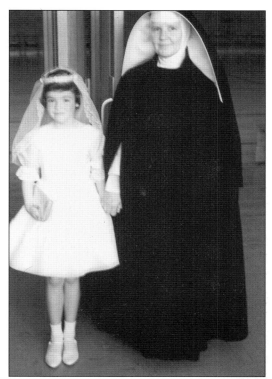

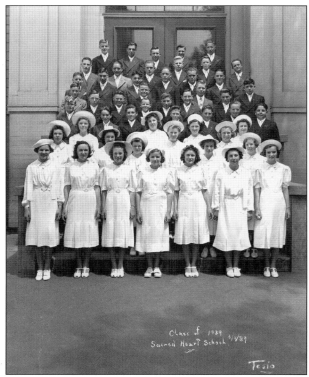

GRADUATION AND CONFIRMATION, 1939. This is the graduating class of Sacred Heart School, soon after students would have received the sacrament of Confirmation. It was a major event in the life of young Italian Americans, the rite of Christian commitment and the deepening of baptismal blessings. Sacred Heart, with its church and school complex, was the main parish of north Oakland's Italian community. (Courtesy of Angie Rainero.)

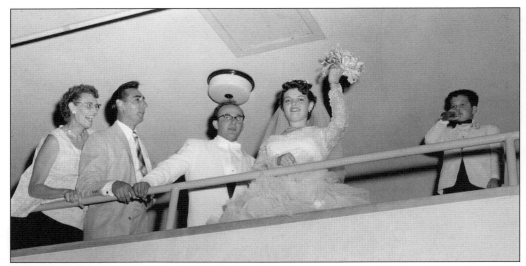

CAMARA WEDDING, 1957. Oakland's Italian American community had its share of wedding ceremonies and receptions. The wedding of Manny Camara and Marie Delgado was one of the biggest—900 people attended and the wedding party, including the bride and groom, numbered 17. As Manny looks on, Marie tosses her bouquet to a bevy of enthusiastic young ladies. Marie's 12-year-old brother, Bob, does not let the festivities take him away from his bottle of soda. The Camara reception, like many others over the years in Oakland, took place at the Colombo Club, Oakland's largest Italian American social club. Marie's grandfather Manuel, upon seeing this photograph, thought she and Manny were on the deck of cruise ship. It is a mezzanine overlooking the Colombo Club ballroom. (Both courtesy of Manny and Marie Camara.)

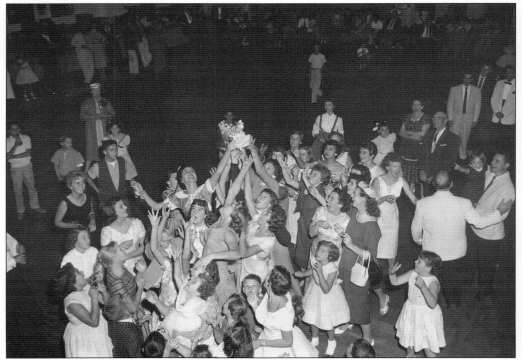

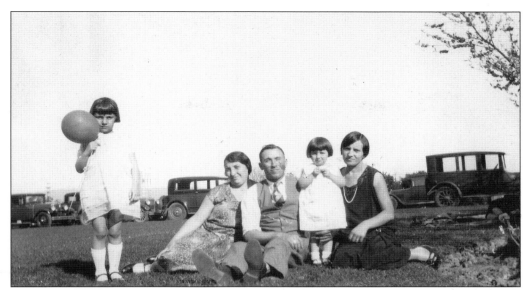

DAY AT THE LAKE, 1928. Lake Merritt in downtown Oakland was a popular destination for Oakland's Italian American residents. Angie Rainero, the girl with the balloon, has fond memories of Sunday outings to the lake. In this photograph, her mother, Rosalina (left), strikes a pose with two neighbors and Angie's younger sister, Hazel. The neighbors, who were childless, "always bought me a balloon," Angie remembers. (Courtesy of Angie Rainero.)

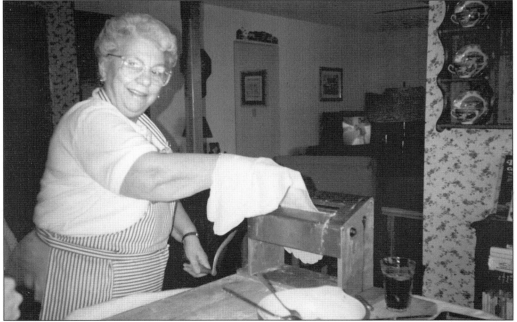

ANGIE'S PASTA MACHINE, 1980s. The girl with the balloon, Angie Rainero, many years later, uses a large and unique pasta machine to roll dough for her signature tortellini, a northern Italian culinary treat. Her father, Fiorentino, an immigrant from Italy's Piedmont region and a machinist by trade, made the machine in the 1960s. Angie lives in Oakland and continues to use the device today. (Courtesy of Angie Rainero.)

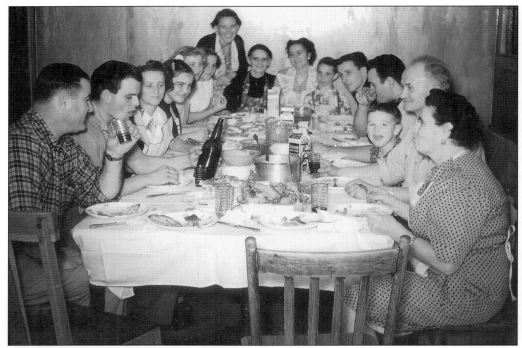

FAMILY DINNER, 1953. The basement of the north Oakland home of Albino (far left) and Gina (standing) DeLazzar was the setting of this Sunday supper. Family members representing three generations gathered to welcome relatives Armando and Lina Fontana (far right), who were visiting from Italy. Adorning the table were roasted chicken, cooked vegetables, pasta by the pot, cartons of milk and, of course, wine. (Courtesy of Janet Carzoli Laurent.)

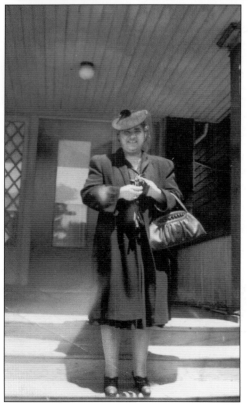

DRESSED FOR THE OCCASION, 1940s. It could have been Sunday Mass, a dinner with family and friends, or another event that Lucia "Lucy" Cuttitta was preparing to attend in this photograph from a family album. She and her husband, Giuseppe "Joe," emigrated from Italy and lived on Forty-eighth Street in Oakland, which was a family gathering spot for decades. (Courtesy of the Cuttitta family.)

Three

MEN—AND WOMEN—
AT WORK

"I came to America because I heard the streets were paved with gold. When I got here, I discovered three things: The streets weren't paved with gold, they weren't paved at all, and I was expected to pave them."

That Italian American saying speaks volumes about the immigrant experience. It has particular relevance to Oakland; many pioneers to Oakland were single men from the Piedmont region of northern Italy. They worked long and hard in a quarry in north Oakland, a quarry whose yield provided much of the pavement and building material for roads, streets, and landmark buildings in Oakland and the East Bay. Other immigrants—predominantly from Italy's Piedmont and neighboring Lombardy regions—worked the streets of Oakland as garbage collectors, first with horse-drawn wagons and later with trucks. It was a common occupation for Italian immigrants: work that had to be done but that few others cared to do. The Oakland Scavenger Company was started by Italian immigrants, provided employment for generations of Oakland Italian Americans, and flourished for many decades. "It was a solid, steady job," says Louie Alberti, a scavenger who rose to be vice president of the company. "It was tough, but we were young, and that's what you had to do."

Italian Americans in old Oakland also plied trades and crafts they brought with them from Italy, adapting them to new surroundings, and did work that was available at the time. They were merchants and grocers; restaurant and delicatessen operators; barbers, cobblers, and bakers; garment workers, field hands, vegetable peddlers, carpenters, stonemasons, and quarry workers.

Easily overlooked in the workplace was the role of Italian American women. They, too, provided a valuable contribution, in fields such as the manufacturing and canning industries and as seamstresses, laundry workers, cooks, and shopkeepers.

In all, Italian Americans, as immigrants and as second- and third-generation citizens, had a vital role in the economic life of Oakland, the San Francisco Bay Area, and all of California.

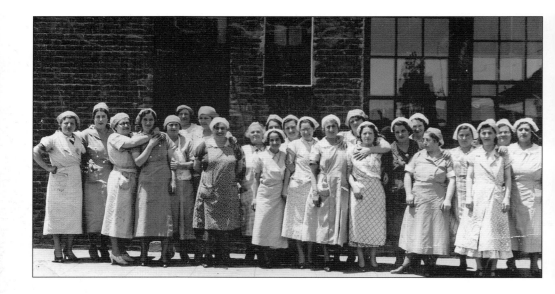

CIGAR FACTORY WORKERS. These women, shown in the 1930s, worked at the Rossi Cigar Factory in west Oakland. Now long gone, the factory employed many residents of Oakland's Italian American community during a time when cigar smoking was commonplace. Popular among older Italian men was a short, dark, twisted cigar called a *cicca* in the Piemontese dialect spoken in Italian Oakland. The Rossi factory employed many women, whose job was to roll cured tobacco into cigars by hand. Many of these same women pose in a later photograph (below) when they met for a reunion. They were not only coworkers, but also good friends and neighbors—as indicated by the smiles and embraces. (Both courtesy of Angie Rainero.)

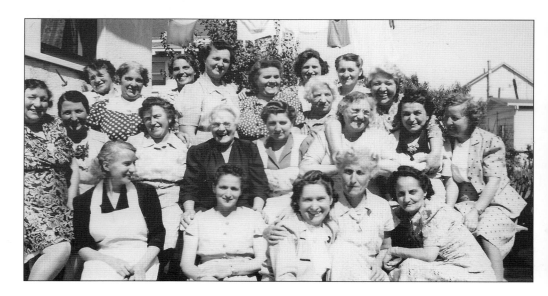

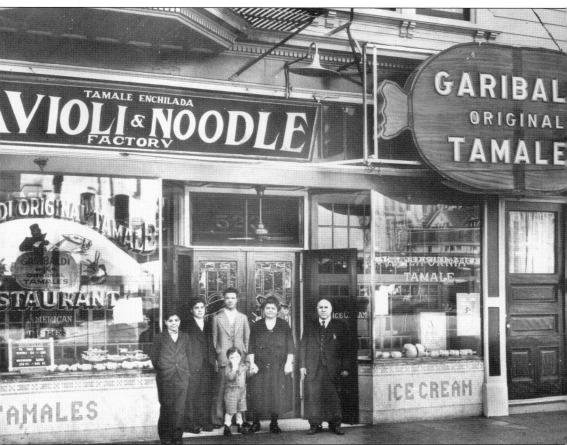

INNOVATION IN ACTION, C. 1920. Mexican and Italian food on the same menu? The melding may have been an indication of Italians' ability to adapt to early California cuisine, but in this case it also testified to Italians' ability to innovate. Sicilian immigrant Vince Truzzolino, when he came to Oakland in 1886 and based on his associations with Mexican residents of California, got the idea to give an Italian twist to the traditional tamale. Instead of an outer layer of corn meal, he encased the tamale filling in a layer of Italian polenta, giving it a unique texture and flavor. Truzzolino's innovation caught on, and tamale parlors popped up in Oakland. The restaurant in this photograph, with wrapped tamales displayed in the windows, was on Eleventh Street in downtown Oakland. Proprietor Carlo DiStefano (far right) poses with his wife and sons. The Garibaldi brand—named after a hero of the 19th-century Italian unification movement—grew in popularity and the tamales are available today in stores throughout California and other Western states. (Courtesy of Frank Maita.)

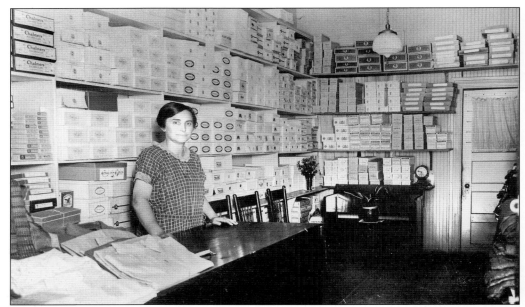

DRY GOODS STORE, C. 1926. Evelyn Ollino kept a neat and tidy dry goods store in Oakland's once active Italian American community. Located at 4995 Broadway, the store served the upper Temescal neighborhood and crews from the nearby Bilger Quarry. The building that housed the Ollino store was demolished with the widening of Fifty-first Street as change began affecting the Temescal district. (Courtesy of Ray Raineri.)

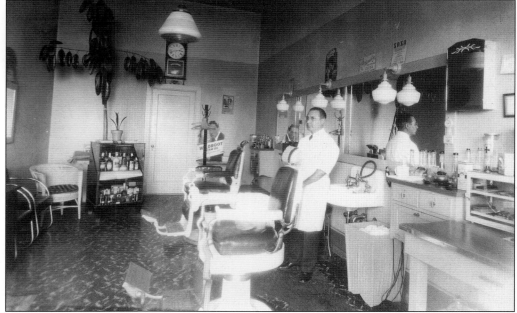

NEIGHBORHOOD BARBER, 1950S. Damiano Tamburrino had four barbershops at different times along College Avenue in north Oakland, serving a largely Italian clientele. He came to Oakland from New York and was originally from a small hill town in central Italy. The shops were named simply "Barber Shop," according to his son Benedetto. (Courtesy of the Tamburrino families.)

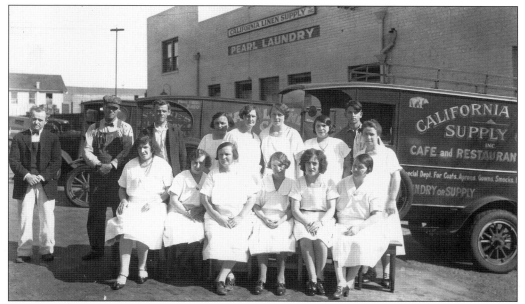

CALIFORNIA LINEN SUPPLY, c. 1928. Italian American women were commonly employed as laundry workers in Oakland. This business, the California Linen Supply and Pearl Laundry, was a large operation established in 1914. As noted by the lettering on the vintage delivery truck, the company specialized in serving industrial clients such as restaurants and cafes. (Courtesy of Ray Raineri.)

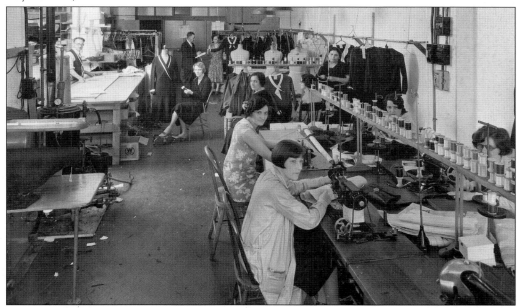

GARMENT WORKERS, 1930s. San Francisco and Oakland had a productive garment manufacturing industry, as illustrated by this photograph of the Marilyn Dress Company in San Francisco. Oakland resident Joseph DeNurra began work here at age 25 as a cutter and pattern grader. The family has a handwritten letter from the company's owner offering Joe a position that would "be steady all year around." (Courtesy of Al and Deanna DeNurra.)

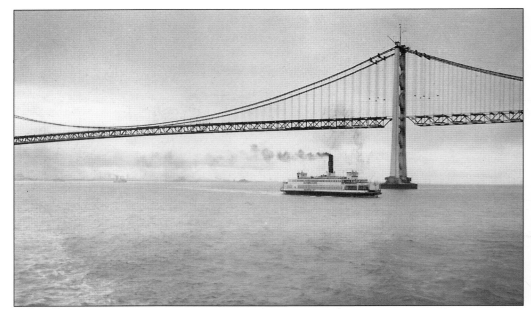

THE NEW BRIDGE, 1936. Joseph DeNurra, a skilled amateur photographer, took this photograph during his commute from Oakland to his job at the Marilyn Dress Company in San Francisco. Before the completion of the San Francisco–Oakland Bay Bridge, Joe and other East Bay residents relied on ferry boats such as the one shown here for transportation across San Francisco Bay. (Courtesy of Al and Deanna DeNurra.)

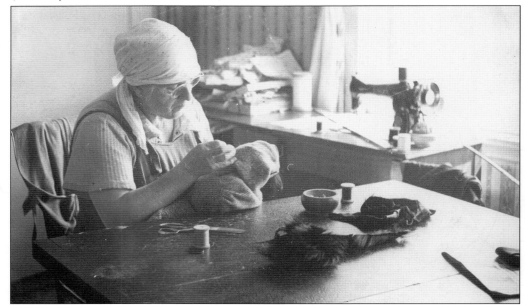

PIECEWORK AT HOME, C. 1945. In the garment industry, male workers generally cut the fabric and women would do the assembly and detail work. They often did this piecework at home. Maria Ferro DeNurra, in this photograph taken by her son Joe, sews coat linings for a shop in downtown Oakland. The DeNurra family home was in Oakland's Italian American Temescal district. (Courtesy of Al and Deanna DeNurra.)

LIBERTY BAKERY, C. 1915. A number of bakeries served Oakland's Italian American community and the East Bay in general. They specialized in sour dough bread but also produced other breads and baked goods as well as cakes and pastries. Shown here is the interior of the Liberty Bakery at Forty-third Street and Telegraph Avenue, with its large brick oven. Co-owner Stefano Persoglio is at right. (Courtesy of Ray Raineri.)

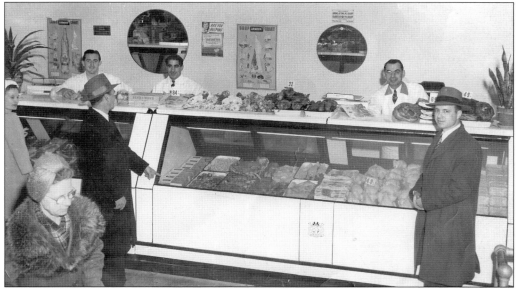

MEAT MARKET, 1946. Joe Scalise (far right) moved from northern California to Oakland and opened his meat market in Alameda in 1935. It provided much of the meat and poultry—including Joe's popular Calabrese-style sausage—served at restaurants in the area and at Oakland Italian American social clubs. Sons Joe and Ron took over the business, which closed in 2009. (Courtesy of Joe Scalise Jr.)

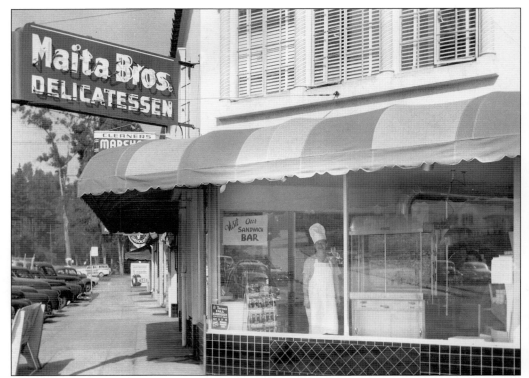

Montclair Deli, 1951. Brothers Frank and Joe Maita, sons of Italian immigrants, ran the family's successful Golden West Restaurant in Oakland's Temescal district. They also opened quick-serve delicatessens in the area, including this one in Montclair village in the Oakland hills. Roasted chickens were a specialty and sold for 98¢ each. That's Joe with his chef's hat in the window. (Courtesy of Frank Maita.)

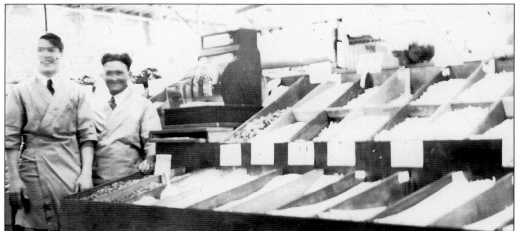

Downtown Produce Stand, 1936. Capwell's department store, once a fixture of downtown Oakland, housed a large market in its lower level. This produce stand did a brisk business and offered goods from surrounding farms and fields worked by Italian Americans. Awaiting customers are clerk Ernie Boegel (left) and part-owner Charles Sanfilippo. (Courtesy of Al and Deanna DeNurra.)

46

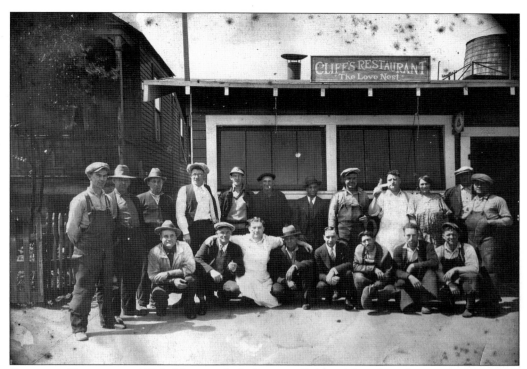

Oakland Teamsters, 1929. Many early Italians in Oakland found work as teamsters. They included Pat Gamba (standing, seventh from left), who joined fellow teamsters at a favorite rest stop, Cliff's Restaurant at Second and Brush Streets in west Oakland. Owners Cliff and Clara Lester are at right. (Courtesy of Louie Celia.)

Loading the Truck, c. 1940. Giuseppe "Gigio" Moglia was one of three brothers who immigrated to Oakland from the Lombardy region of northern Italy. He was an Oakland scavenger, and here he totes a sheet of burlap, called a *quertina*, laden with refuse to a waiting truck. With him is coworker Mike Sportorno. (Courtesy of Yoli Moglia.)

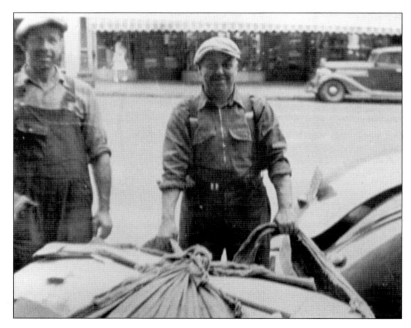

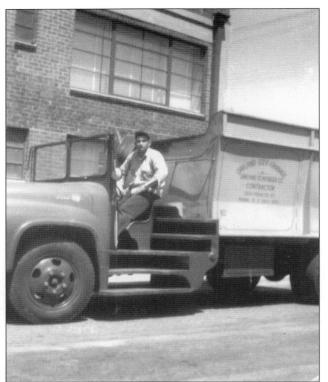

SUMMER WORK, 1959. The men in John Peter Moglia's family had come to Oakland from villages in northern Italy and worked as garbage collectors for the Oakland Scavenger Company. He did the same during the summers and breaks from school and went on to become a high school teacher for 20 years. (Courtesy of Yoli Moglia.)

NO JOY RIDE, 1911. Despite the bicycles and the fellow sipping from what could be a bottle of wine, this is serious business—a team of Oakland scavengers ready to begin their monthly payment collections. They rode bikes to do this, while one of them kept time. The men were most likely recent immigrants. (Ted Wurm collection; courtesy of Ray Raineri.)

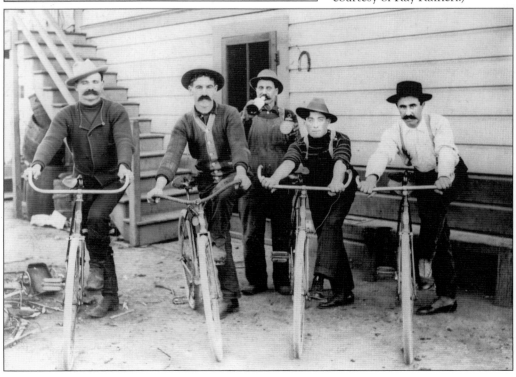

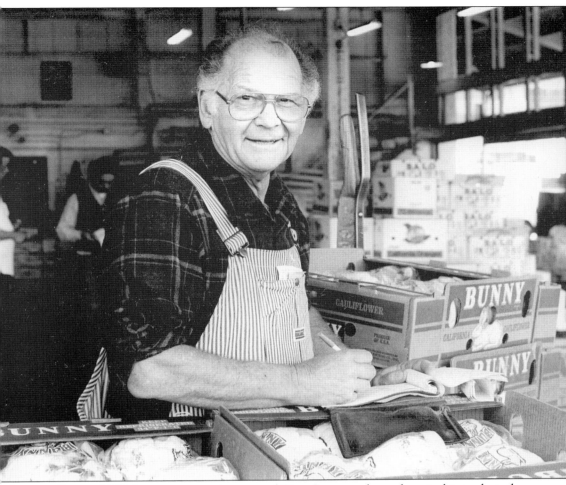

SUCCESS STORY, 1989. In many ways, the story of Gino Zanotto, shown here in his trademark striped overalls when he retired at age 63, typifies the progress of second-generation Italian Americans. The son of immigrants to Oakland, he was 15 when he began working in Oakland's bustling wholesale produce district near the Jack London Square waterfront. From 3:00 a.m. to 8:00 a.m., he loaded, unloaded, and moved boxes of vegetables and fruit on a hand truck; forklifts did not exist. For the rest of the day, he attended classes at Oakland's Technical High School. That first year in the produce business, Gino earned $547. He stuck with it, worked his way up, and by the 1970s he was co-owner of the Felix Cohen Wholesale Company. "It takes hard work and long hours to be a successful produce operator," Gino, now deceased, said in an *Oakland Tribune* profile article. (Courtesy of Elma Casale.)

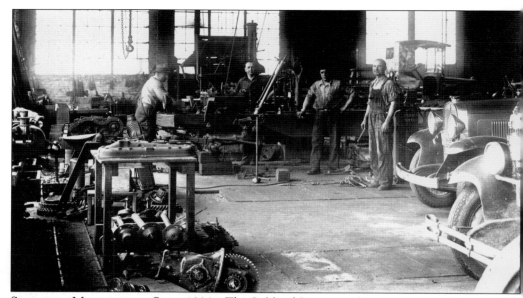

SCAVENGER MAINTENANCE SHOP, 1920s. The Oakland Scavenger Company was a major operation until the corporate waste management industry came along in more recent times. The Oakland company had its own foundry and maintenance operation on Peralta Street in west Oakland, where workers rebuilt and repaired garbage trucks. In earlier times, workers repaired wagons and shoed horses in the same shop. (Courtesy of Louie Alberti.)

GARBAGE SCOWS, 1930s. Oakland scavengers for many years hauled garbage in horse-drawn wagons and then in trucks to the foot of Adeline Street on the Oakland waterfront. Heavily loaded scows would then carry the refuse 25 miles out to sea and unload. "That was the only way we knew how to do it back then," recalls Louie Alberti, a former scavenger company executive. (Courtesy of Louie Alberti.)

PRODUCE MARKET, 1978. Smiling Al Spingolo was well known in Oakland's produce market when Italian Americans dominated the business. He worked as a teenager with his father at the once-bustling wholesale marketplace in the historic Jack London Square district. Al started the workday long before dawn, toting 100-pound sacks of potatoes and heavy wooden crates packed with fresh fruit and vegetables, such as these California-grown asparagus. (Courtesy of Marianne Spingolo.)

EARLY SCAVENGING TRUCK, C. 1920. By the 1920s, scavengers in Oakland were using trucks to haul garbage—but still picking it up by hand in burlap blankets and later with large bins slung over their shoulders. The truck shown in this photograph with its team of scavengers had thin tires made of hard rubber. Thicker tires came along later. (Courtesy of Louie Alberti.)

EAST OAKLAND ROUTE, 1920s. Brothers Pete and Steve Perata, both Italian immigrants, earned their living as scavengers, working mostly in east Oakland. Like other scavengers, they started out hauling garbage by horse-drawn wagons. By this time, they were able to move up to a truck. Early garbage trucks had hard rubber tires. (Courtesy of John Tandi.)

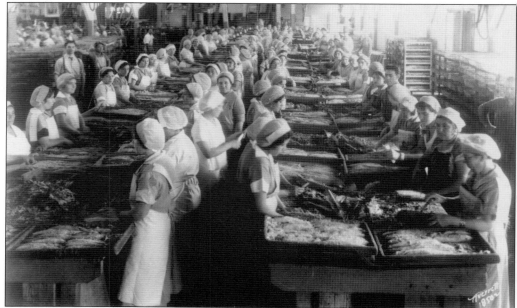

ON THE LINE, C. 1940. These were among the many Italian American women who worked on production lines at canneries in Oakland, especially in the 1940s when many men were serving in the armed forces during wartime. Two of Oakland's largest food processing employers at the time were the Lusk Canning Company in the predominantly Italian Temescal district and Del Monte Foods in the Fruitvale district. (Courtesy of John Penna.)

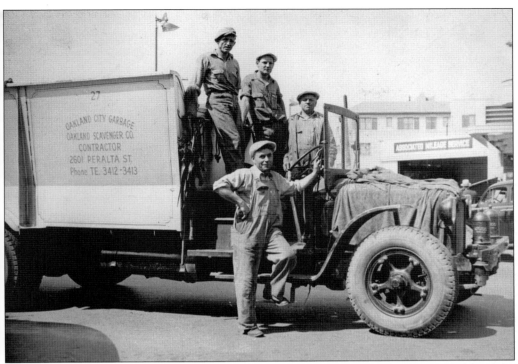

SCAVENGER TEAM, 1940s. On their route in the Lake Merritt area of downtown Oakland are Giovanni Moglia (front), whose nickname was Pullo, and (from left to right) Baci Spinetta, Ernest Repetto, and Baci Fagliano. Originally immigrants from northern Italy, the men were residents of Oakland's Italian American community. (Courtesy of Yoli Moglia.)

LIVERY STABLE, 1919. James Dito, the son of Italian immigrants, was born in San Francisco and moved to Oakland after the 1906 fire and earthquake that destroyed much of the City by the Bay. "He loved animals," remembers his niece, Marianne Spingolo. Dito remained in Oakland, working at this livery in west Oakland in younger days and later at Oakland's shipyards. (Courtesy of Marianne Spingolo.)

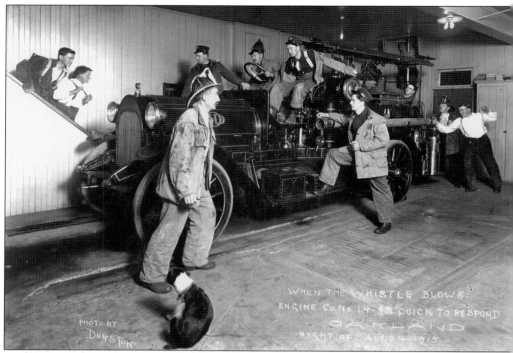

RAPID RESPONSE, 1915. The fellow at the far right is believed to be Andrew Giambroni, an Italian immigrant grocer in Oakland's Dimond district who also served as a volunteer firefighter. The inscription on this vintage photograph notes that Engine Company No. 14 was responding to an alarm on the night of August 24, 1915. The only one not scrambling to action was the firehouse dog (foreground). (Courtesy of Jess Giambroni.)

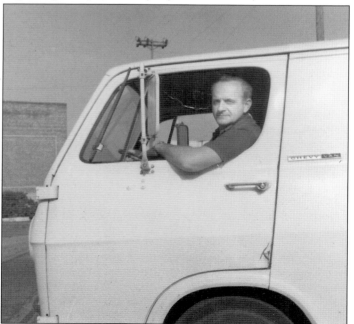

WINDOW WASHER, 1967. Many Oakland Italian Americans started their own businesses as janitors and window washers. A prime example is Leroy Casale, shown here in his work van. A native of Oakland, he is a past president of the Ligure Club and a leader in the Italian Catholic Federation. His son Paul is an Oakland dentist who serves a largely Italian American clientele. (Courtesy of Leroy Casale.)

Four

SERVICE TO COUNTRY

Throughout the history of the United States, even during the Revolutionary War, men and women of Italian descent have fought to protect the country they called home, whether as immigrants or sons and daughters of immigrants. According to the National Italian American Foundation, more than 300,000 Italian Americans served in World War I and an estimated 1.5 million in World War II. Italian Americans from Oakland and the East Bay were among these forces, many of them serving valiantly in combat.

Many of the Italian American men who served in the military during World War I joined the war effort after having come to the United States from Italy as teenagers. Many of them enlisted and fought overseas, proud to serve their adopted country. Fiorentino Aletto, for example, was 16 when he came to Oakland from a village in Italy's Piedmont region. He served in France in 1918 and returned to Oakland uninjured, where he married, started a family, and spent the rest of his life. Lucy Sandretto joined the U.S. Army Air Corps to escape farm life in Idaho and worked in the equipping of combat aircraft in World War II, a move that brought her to the Oakland area and the East Bay Italian American community. Ernie Raimondi, one of three sons of Italian immigrants, was a promising minor league baseball player in Oakland when he joined the U.S. Army in 1942. He was killed in action in France. Peter Cuttitta, also the son of Italian immigrants, grew up in Oakland and served in both World War II and the Korean War. In the Philippines during World War II, his amphibian tank unit joined in the liberation of the infamous Los Banos prison camp. A decorated veteran, he retuned to Oakland where he raised a family and taught high school for 39 years.

These are examples of the many Italian Americans who served their country in the armed forces and continue to do so today.

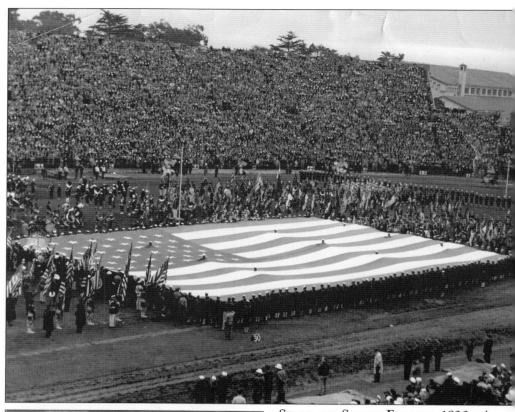

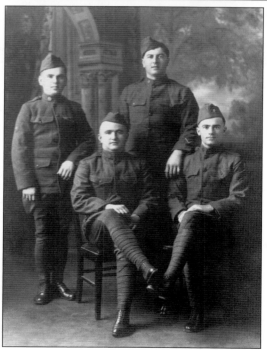

STARS AND STRIPES FOREVER, 1930s. A huge crowd pays tribute to the U.S. flag. Veterans and active military personnel, many of them most likely Italian Americans from Oakland, helped carry this flag and otherwise participated in this patriotic event believed to have taken place on a national holiday such as Memorial Day at San Francisco's old Kezar Stadium. (Courtesy of Angie Rainero.)

ITALIAN AMERICAN DOUGHBOY, 1917. Fiorentino Aletto (far left) had emigrated from the Piedmont region of northern Italy and was settled in Oakland when World War I broke out. Like many other Italian immigrants, he joined the U.S. Army to do his part for his newly adopted country. He is pictured here with unidentified army buddies. (Courtesy of Angie Rainero.)

BASIC TRAINING, C. 1917. Troops at Fort Myer, Virginia, prepare for inspection as women and others look on. Fiorentino Aletto kept this photograph after returning from World War I. An immigrant to Oakland from northern Italy, he served in the U.S. Army and went through basic training at Fort Myer. (Courtesy of Angie Rainero.)

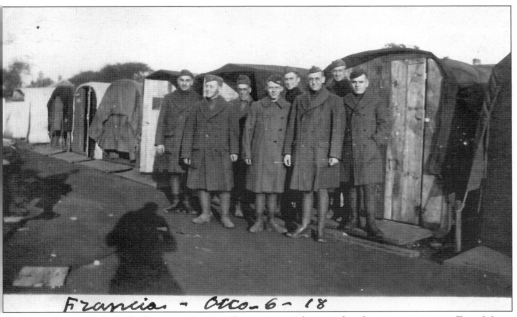

Francia ~ Occo-6-18

ON THE FRONT, 1918. Italian immigrant Fiorentino Aletto, after basic training at Fort Myer, Virginia, was shipped to fight in France. His handwritten inscription on this photograph reads, "France, October 6, 1918," though he used "Francia," the Italian spelling for France. He was one of 300,000 Italian Americans who served in the U.S. military during the war. (Courtesy of Angie Rainero.)

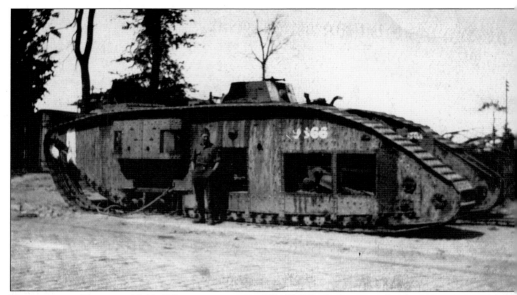

REMNANT OF BATTLE, 1918. This is among the World War I photographs that Fiorentino Aletto either sent back to Oakland, where he lived after emigrating from Italy, or took back with him, and that his daughter Angie has saved over the years. The battleground was in France, and the piece of equipment is a disabled tank. (Courtesy of Angie Rainero.)

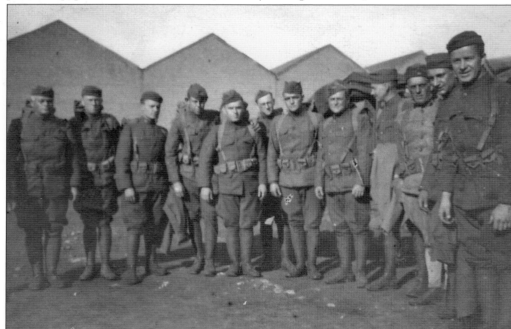

COMRADES IN ARMS, 1918. A fellow doughboy puts his arm around Fiorentino Aletto, center, in this photograph from France. Fiorentino, who emigrated from Italy and settled in Oakland as a teenager, served in the U.S. Army during World War I. These troops are prepared for battle; 10 percent of casualties in World War I had Italian surnames. Fiorentino returned to live a full life in Oakland. (Courtesy of Angie Rainero.)

VALIANT VETERAN, 1950. Pietro 'Peter" Cuttitta, whose Italian immigrant parents were residents of Oakland's Temescal district, served in combat in both World War II and the Korean War. In this studio portrait, he is shown before leaving for Korea in 1951. In World War II, he served in the Pacific Theater as part of the 672nd Amphibian Tractor Battalion. The group joined in the historic 1945 raid on the Los Banos Interment Camp in the Philippines. One of the most daring raids of the war, it freed 2,147 Allied civilians, including women and children, and military internees. Peter returned from Korea to Oakland, where he raised a family with his wife, Virginia, and taught biology and physiology at Oakland Technical High School for 39 years. He died in 2010. (Both courtesy of the Cuttitta family.)

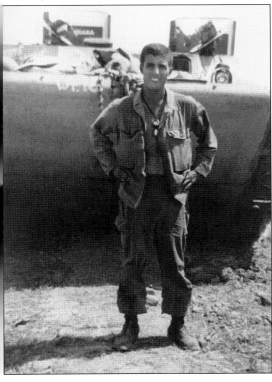

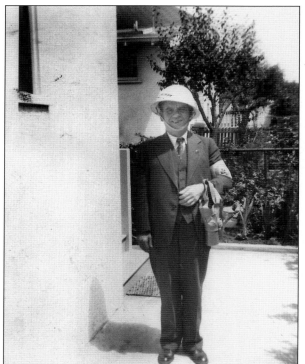

Service on the Home Front, 1940s. During World War II, Californians feared a Japanese attack, and air raid drills were conducted with the help of block wardens such as Oakland's Fiorentino Aletto. An Italian immigrant who served in the U.S. Army during World War I, he led neighbors to his basement during drills. While they waited, according to his daughter Angie, he would serve wine and snacks. (Courtesy of Angie Rainero.)

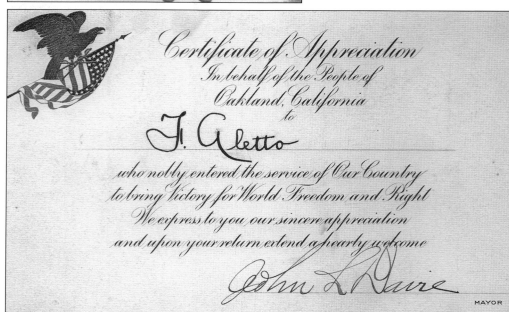

OFFICIAL COMMENDATION, c. 1918. Oakland mayor John L. Davie presented this certificate of appreciation to Fiorentino Aletto for his service "to bring victory for world freedom and right" during World War I. Fiorentino had immigrated to Oakland from Italy before the outbreak of the war. He served in France and lived in north Oakland's Temescal district until his death. (Courtesy of Angie Rainero.)

WOMEN WHO SERVED, 1944. Lucy Sandretto, one of many Italian American women who served in the armed forces, joined up at age 24, she says, mostly to escape farm life in Idaho. She enlisted in the Women's Air Corps and was stationed in the San Francisco Bay Area, where she kept inventory for aircraft parts and later settled in the Oakland area. (Courtesy of Lucy Sandretto.)

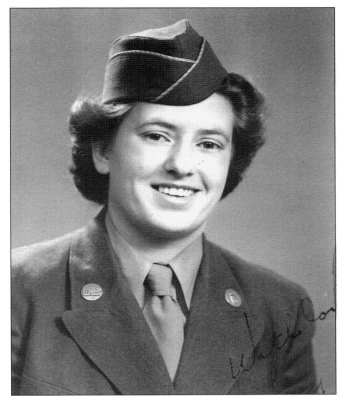

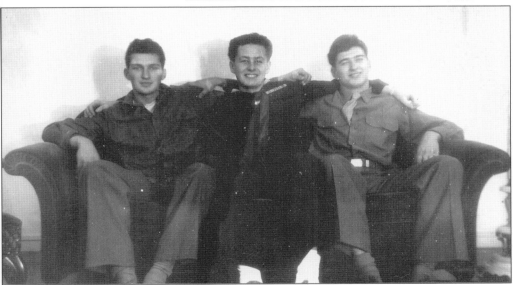

THREE FRIENDS, THREE BRANCHES, 1945. These three friends, sons of Italian immigrants, grew up together in Oakland and served during World War II in different branches of the armed forces. They are, from left to right, Emil Firpo, who was in the U.S. Army; Dick Cadematorri, who served in the U.S. Navy; and Felix Biggi, a member of the U.S. Air Force. (Courtesy of Bonnie Cunha.)

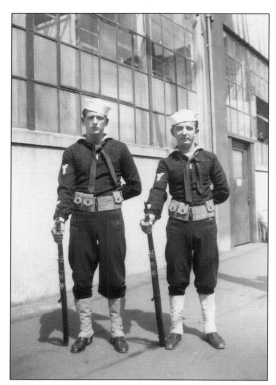

COAST GUARD PATROL, 1940s. John Rainero (right) enlisted in the U.S. Coast Guard in 1942. A native of Oakland's Italian American community, he did his duty close to home, in the San Francisco Bay Area. It was wartime and California was on alert for a possible Japanese attack. (Courtesy of Angie Rainero.)

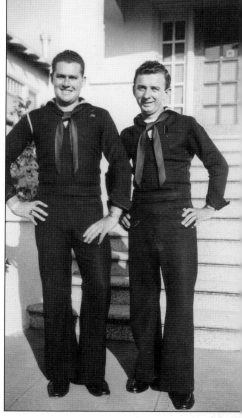

VISITING HOME, 1940s. Two pals who grew up together in the Temescal district, Oakland's Italian American neighborhood, and later entered the U.S. Coast Guard take a break from service to visit family and friends in the old neighborhood. They are John Rainero (left) and John Rusconi. (Courtesy of Angie Rainero.)

BACK IN THE NEIGHBORHOOD, 1940s.
Three unidentified servicemen share a happy visit during World War II with Ed Gale at the home of his in-laws, the Lavazzi family, on Desmond Street in north Oakland. The family built the home, their first, in 1926. "They were so proud of that house," says Karen Garcia, Ed's daughter. (Courtesy of Karen Garcia.)

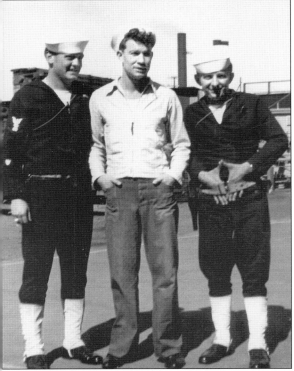

ON THE WATERFRONT, 1940s.
John Rainero (right) poses here with unidentified fellow Coast Guardsmen. He was born and raised in Oakland's Italian American Temescal district and enlisted in the U.S. Coast Guard in 1942. He was assigned to patrol duty in San Francisco and elsewhere in the Bay Area. (Courtesy of Angie Rainero.)

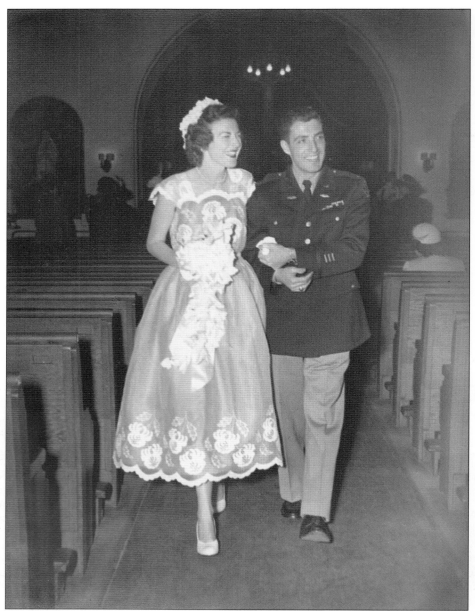

DOWN THE AISLE, 1951. Peter Cuttitta was about to leave for army duty in Korea when he and Virginia Jones were married at St. Theresa's Catholic Church in Oakland. The son of Italian immigrants who made their home in Oakland, Peter was one of 1.5 million Italian Americans who served in the military during World War II. He saw combat in both World War II and Korea. During World War II, he fought with an amphibian tank division in the Philippines and participated in the liberation of the Los Banos Internment Camp from the Japanese. It was one of the most daring raids of the war. Back home, Peter taught biology and physiology at Oakland Technical High School for 39 years. "That's where he met my mom, who taught English and history," says their daughter Cecile. "They were the Miss Brooks and Mr. Boynton of Tech." Peter died in 2010. (Courtesy of the Cuttitta family.)

Five

TEMESCAL,

THE OLD NEIGHBORHOOD

For Italian Americans, a swath of north Oakland known as the Temescal district had everything they could want or need and then some. At its height, roughly from the 1920s through the 1950s, it was the hub of Oakland's Italian American community, a place, according to local historian Ray Raineri, where Italians who first lived in west Oakland and other areas of the city aspired to "move up to" to buy or build a home, have a yard and gardens, and raise a family.

The name Temescal most likely derives from the Native American word for a sweathouse, which may have been one of the first structures in the area; it is also the name of a creek that runs through the area. Italians in the old days, however, called the area simply north Oakland, or the neighborhood. It had shops, markets, and stores of every kind, as well as banks, medical and law offices, public transportation, bars, schools, barbershops and beauty salons, a movie theater, a major amusement park, and social clubs with bocce courts, ballrooms, and banquet halls.

Temescal businesses were mostly owned and operated by Italians. Entire streets had Italian residents; one street, Cavour, was named for a hero of the movement that unified Italy in 1860. The smells, sights, and sounds were Italian, and the Italian language, or dialects of it, was spoken on streets and in homes.

Temescal native Angie Rainero recalls that many residents, including her parents, came to Oakland from Italy "with very few worldly goods and little money . . . They were very hard workers, very ambitious and enterprising people."

Ed Basso, a well-known and beloved figure in the Oakland Italian American community, has this recollection of Temescal in the old days: "It was wonderful. Nobody had money; we were all poor in dollars. But in family life we had everything—gourmet dinners, kids could play in the street, we'd go to movies for 10 cents at the Claremont Theater, you could walk the streets at two or three in the morning, and you never had to be afraid of anything. We never locked our doors."

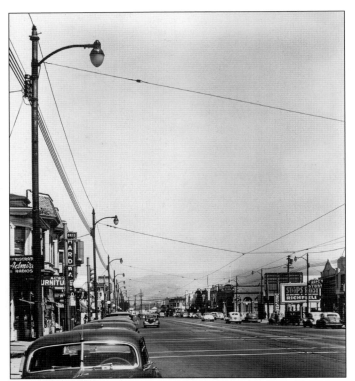

HEART OF TEMESCAL, 1947. Telegraph Avenue at Forty-eighth Street was the center of Oakland's Italian American neighborhood. Residents represented different parts of Italy but predominantly the regions of Piedmont and Liguria. Most shops and other businesses were either owned or staffed by Italian Americans. Streetcars used overhead wires and double tracks, but this rail service ended in 1948. (Courtesy of Ray Raineri.)

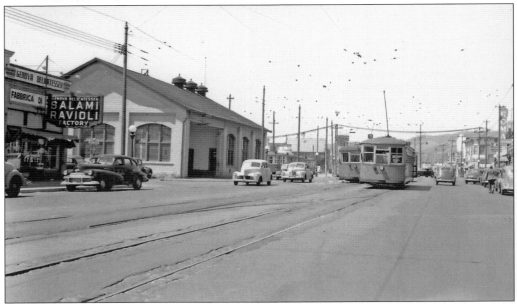

END OF THE LINE, 1948. Streetcar service in the Temescal district ended in 1948, signaling the start of changes that would transform the old neighborhood and alter its Italian character. One thing that remains to this day is the Genova Delicatessen (left), although it has moved to larger and more modern quarters on the same block of Telegraph Avenue. (John Harder collection; courtesy of Ray Raineri.)

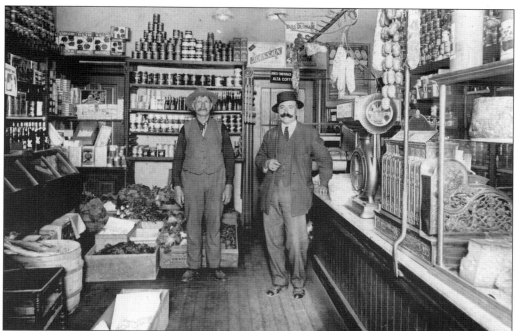

ORIO GROCERY STORE, C. 1910. These two views show the exterior and interior of Cesare Orio's grocery store at Fiftieth Street and Telegraph Avenue. In the interior view, Orio (left) is joined by his partner and son-in-law Stefano Persoglio. In the exterior view, Orio is the tall man in the center; the sign in the window at the left indicates that his wife provided dressmaking and millinery services. The Orio store sold a wide variety of goods, including the fresh vegetables in boxes on the floor and the salami and other cured meats hanging on pegs above the counter with its ornate scale and cash register. The barrel at the far left seems to contain *bacala*—codfish cured in salt—a Genovese specialty. (Both courtesy of Ray Raineri.)

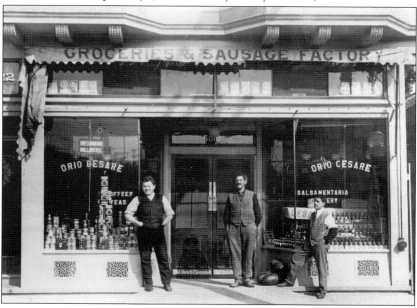

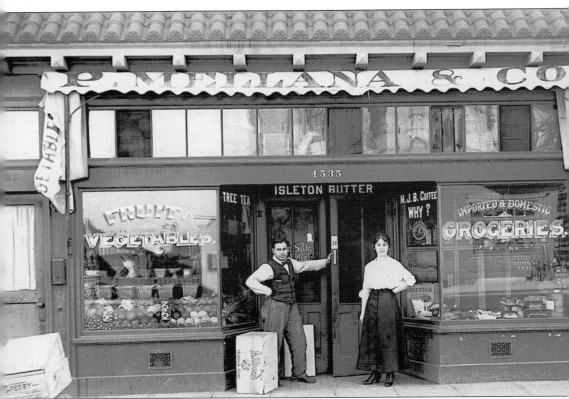

P. MELLANA AND COMPANY, C. 1915. Peter Mellana and his wife, Mary, owned and operated this and another grocery store on Grove Street in the Temescal district. The 1906 San Francisco earthquake and fire brought them to Oakland—"I think Dad had been courting my mother at the time," says their son Ray—and they were married in 1912. Peter had emigrated from the Piedmont region of northern Italy when he was about 17 years old. Ray notes that his parents ran the popular stores for 30 years "without any closures for vacations or illnesses." Ray and his younger sister Hazel were born in rooms above the second store, which became the family home for 35 years. Ray, who became a lawyer and civic leader, says, "My parents were part of a close-knit community that spoke Italian almost exclusively—on the streets, and in the stores, and in their own store." (Courtesy of Ray Mellana.)

MELLANA DELIVERY TRUCK, 1920S. Temescal grocer Peter Mellana was proud of his Model T truck. The bed had benches for passengers and groceries and curtains to protect both. In poor weather, Peter shuttled the Mellana children, Ray and Hazel, and sometimes their friends, to and from school. Recalls Ray, "Dad never objected since he seemed to enjoy the ride and his merry passengers." (Courtesy of Ray Mellana.)

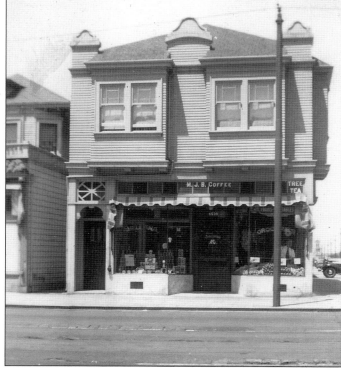

MELLANA HOME AND STORE, 1938. "The Old Homestead," is Ray Mellana's description of this building on Grove Street in the Temescal district. The upper level was the family home—he was born there in 1919, his sister, Hazel, in 1921. After buying the building, the Mellanas had it elevated and a store built on the ground floor. (Courtesy of Ray Mellana.)

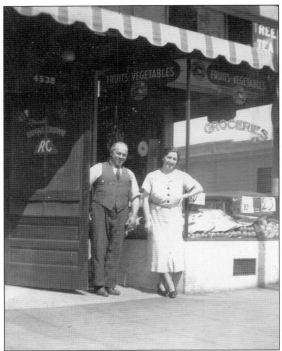

MELLANA STORE, 1940s. Peter and Mary Mellana take a break outside their Grove Street grocery market in the heart of the Temescal district. Immigrants from northern Italy who came to Oakland from San Francisco after the 1906 earthquake, the Mellanas ran this and another store for 30 years and raised two children, Ray and Hazel, in quarters above this store. (Courtesy of Ray Mellana.)

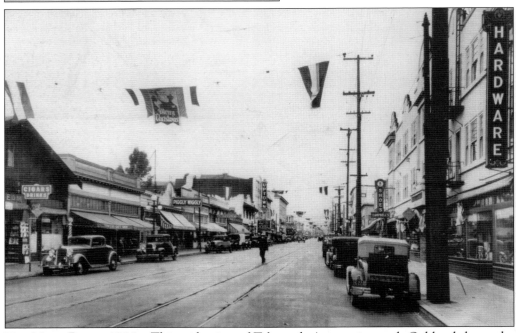

THE MAIN DRAG, 1930s. This wide view of Telegraph Avenue in north Oakland shows the center of Oakland's once-vibrant Italian American neighborhood. The hardware store sign still exists, but the building now houses two popular eating places and small shops. An anchor of the old neighborhood, despite many changes, continues to be the Genova Delicatessen near the intersection of Fifty-first Street and Telegraph Avenue. (Courtesy of Elsie Giuntoli.)

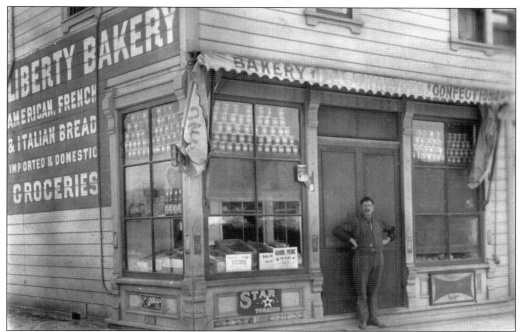

LOCAL MOGUL, C. 1915. Temescal businessman Cesare Orio stands outside his Liberty Bakery at 4298 Telegraph Avenue. He had earlier operated the Original Italian and French Bakery in west Oakland, another Italian American enclave. His partner was son-in-law Stefano Persoglio. They also ran a grocery store a few blocks away on Telegraph Avenue. (Courtesy of Ray Raineri.)

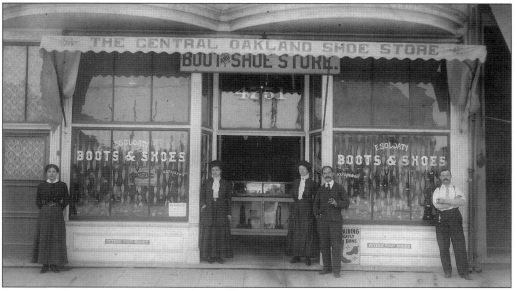

BOOT AND SHOE STORE, C. 1912. Many Italian immigrants were adept at boot and shoemaking, and Felix Soldati (second from right) had a busy shop in the Temescal neighborhood. Holding an Italian-style cigar in his hand, he poses with unidentified family members who also worked in the Telegraph Avenue shop. "Repairing neatly done," the sign behind him reads. (Courtesy of Ray Raineri.)

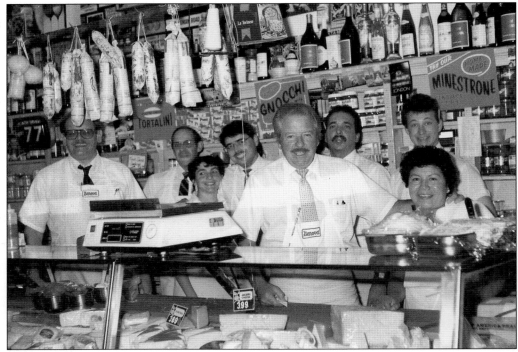

ICON OF THE AVENUE, 1970s. Established in 1926 by Italian immigrant partners, the Genova Delicatessen has grown to iconic status in Oakland's Italian American community. Dominic DeVincenzi (above, center) has run the business since the 1950s, moving the deli in the late 1990s from its original location, shown below, to larger, modernized quarters next door. Genova is widely known in the Easy Bay for its fresh-made delicacies, including hefty cold-cut sandwiches made on the spot and its ravioli, gnocchi, and tortellini made fresh at a nearby plant, along with trademark meat and pesto sauces. Genova's signature ravioli are sold in markets around the Bay Area. The Genova deli counter is busy all day, with customers lined up for personal service from Dominic and his crew. (Both courtesy of Dominic DeVincenzi.)

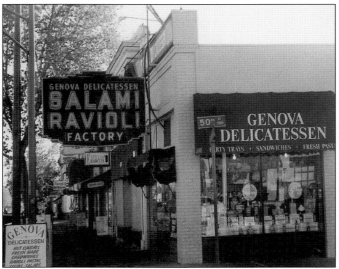

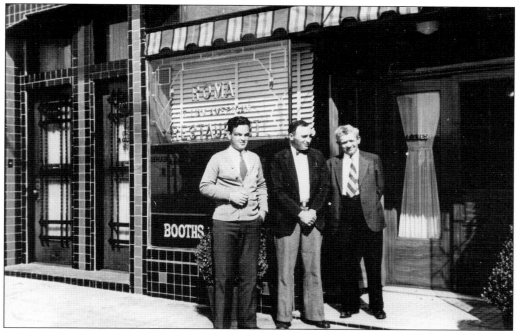

ROMA CAFÉ, c. 1935. The Roma Café, seen here in exterior and interior views, was one of Temescal's finest restaurants. Its owner was Felix Croce (above, far right); next to him are Angelo Conte (center) and an unidentified patron. With its long and well-stocked bar, the Roma, at Fifty-first Street and Telegraph Avenue, was known widely as a place to meet and enjoy Italian meals. Aldo Guidotti, a lawyer and civic leader who began his practice in the Temescal district in 1946, recalls that the Roma was "equivalent to what you find in (San Francisco's) North Beach," adding that business people from downtown Oakland frequently met for lunch at the Roma. (Both courtesy of Ray Raineri.)

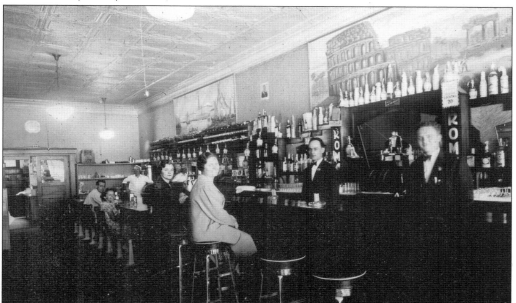

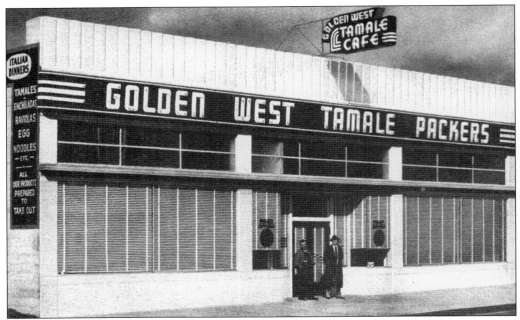

GOLDEN WEST TAMALE CAFE, 1940s. Italian and Mexican food combined in this popular Temescal eatery owned and operated by brothers Frank and Joe Maita. Their uncle, a Sicilian immigrant, gave an Italian twist to Mexican tamales and the result was a hit. A vintage Golden West menu shows that a New York steak dinner, including dessert, cost $2.75. (Courtesy of Frank Maita.)

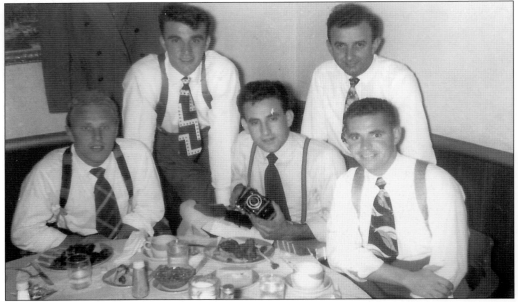

TEMESCAL PALS, 1940s. These young men, all or most of them sons of Italian immigrants and natives of the Temescal district, are enjoying a special meal at one of the area's many restaurants, possibly the Roma Café or the Golden West. Those who can be identified are Mike Ghiorso (second from left), Ray Damele (seated, center), and John Rainero (standing at right). (Courtesy of Angie Rainero.)

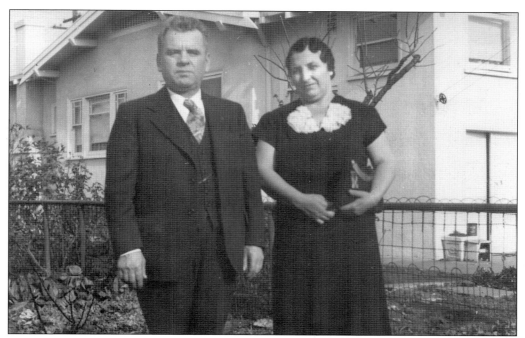

ALETTO ANNIVERSARY, 1946. Longtime Temescal residents Fiorentino and Rosalina Aletto are seen here in the backyard of their Forty-sixth Street home on their 25th wedding anniversary. They were married in the Temescal district in 1921 after Fiorentino emigrated from Italy's Piedmont region and his bride from the Tuscany region. They raised two daughters in the neighborhood, Angie and Hazel. (Courtesy of Angie Rainero.)

GRAPE CRUSHER, 1930S. Fiorentino Aletto (right), a machinist, used his skill and ingenuity to build portable grape crushers that he rented to fellow Italians in the Temescal area. He displays one of the crushers here. "I used to love watching my father crush the grapes," former Temescal resident Ray Mellana recalls. "In all of Temescal, in all the homes, people were making wine—the fumes!" (Courtesy of Angie Rainero.)

DRESSED FOR DRILL, C. 1945. Elsie Giuntoli, a native of the Temescal district, poses in her uniform as a member of the Italian Catholic Federation, Branch 40, girls drill team. The federation, which was affiliated with Temescal's Sacred Heart parish, was one of several Italian American social and cultural organizations in Oakland. It continues today and Elsie is an active member. (Courtesy of Elsie Giuntoli.)

DRILL TEAM, C. 1945. Members of the Italian Catholic Federation, Branch 40, girls drill team gather for a photograph. Elsie Giuntoli (standing, far right) thinks the young man with them was someone's beau. The team performed at parades and other special events. "Those were really fun days," Elsie remembers. (Courtesy of Elsie Giuntoli.)

GRAMMAR SCHOOL CLASS, 1929. These youngsters comprised a class at Emerson Elementary School, a Temescal public school attended by children of mostly Italian and Irish descent. This class included John Rainero (third row, third from left). His father, Giuseppe, was a founder of the Colombo Club, which began in the Temescal district and is Oakland's oldest and largest Italian American social club. (Courtesy of Angie Rainero.)

SACRED HEART CLASS, 1930. Sacred Heart church and elementary school were beloved institutions in the Temescal district. This rare photograph of a first grade class, with boys and girls in separate sections, has inset images of the stone church and school buildings flanking a photograph of Monsignor Sampson. The church was damaged beyond repair in a 1980s earthquake and subsequently replaced, along with the school building. (Courtesy of Angie Rainero.)

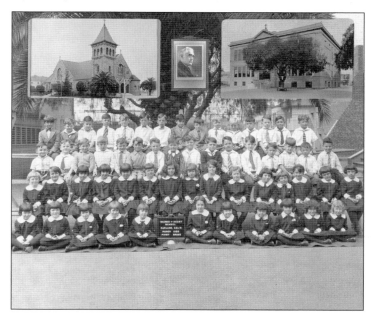

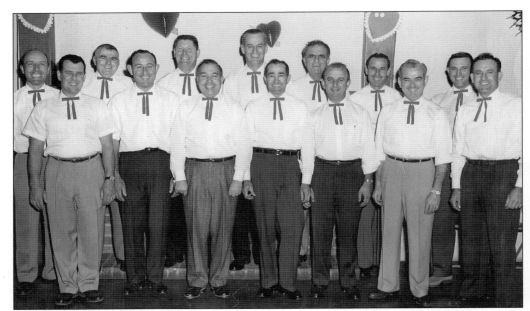

RED TIE BRIGADE, 1950s. This group of smiling Temescal pals, all sporting red bowties for a Valentine's Day celebration, grew up together and went to World War II together. When they returned, they decided to form a "stag club." They met monthly at the Ligure Club, one of Oakland's Italian American social clubs, and conducted annual dinner-dances at the club. (Courtesy of Angie Rainero.)

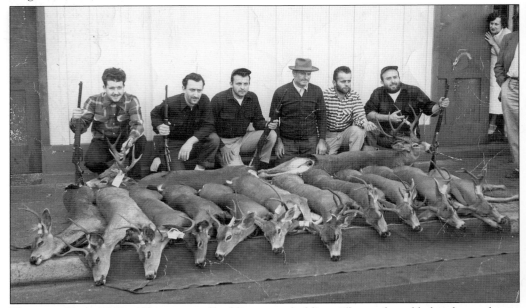

HUNTING TRIP, 1940s. This group of buddies, some holding rifles, gathered behind a market in the Temescal district to display the result of a productive hunting trip to northern California. They attracted stares as they hauled the catch by truck along city streets. From left to right are Dominic DeVincenzi, Leo Carlevaro, Leroy Casale, Louie Raineri, Al Raineri, and Les Garibaldi. (Courtesy of Leroy Casale.)

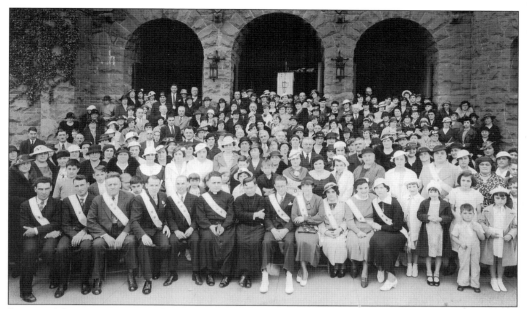

ITALIAN MISSION, 1936. Gathered outside Temescal's Sacred Heart Church, this is the formally attired membership of Branch 40 of the Italian Catholic Federation. The parish sponsored visits by Italian missionary priests who led faith-based discussions and said Mass in Italian. Seated fourth from left is Felix Chialvo, a Temescal civic leader who would become a member of the Oakland City Council. (Courtesy of Angie Rainero.)

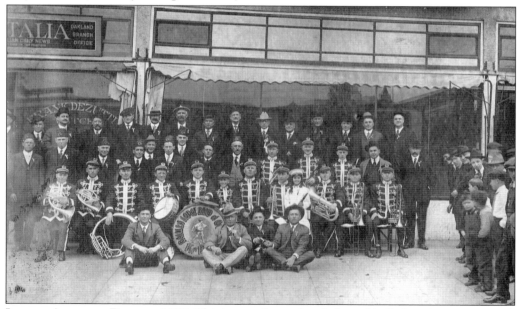

ITALIAN AMERICAN BAND, C. 1920. This is one of many bands formed by Italian American social, cultural, and fraternal organizations in Oakland. The affiliation of this group and identities of its members are lost in history, although the girl dressed in white is believed to be Julia Persoglio, whose family was prominent in Oakland's Italian community. The setting is the Temescal district. (Courtesy of Karen Garcia.)

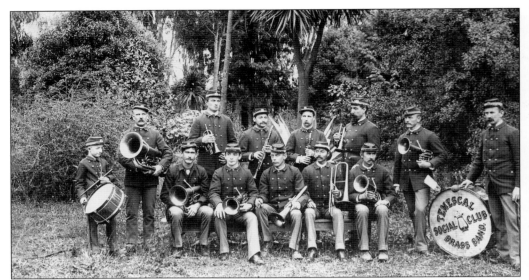

TEMESCAL BAND, C. 1980. It is unknown whether Italians were members of the Temescal Social Club Brass Band this far back, but the existence of the band certainly illustrates the vibrancy of the Temescal district, which became a predominantly Italian American neighborhood. Temescal was a separate township from Oakland until around 1908. This park later would become Oakland's famed Idora Park amusement area. (Ted Wurm collection; courtesy of Ray Raineri.)

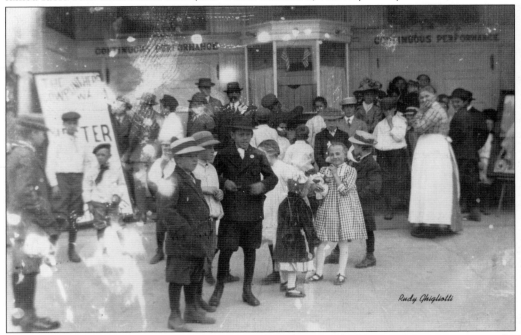

FUN AT THE MOVIES, C. 1915. This theater may have been in the Temescal district or in nearby downtown Oakland. Some of the excited youngsters surely were of Italian descent, as was the photographer; his name, Rudy Ghigliotti, appears in script at the lower right. Judging from the faint lettering on the display board, the movie generating this excitement seemed to be *The Cowpunchers*, a rollicking Western released in 1915. (Courtesy of Karen Garcia.)

Six

"SEE YOU AT THE CLUB"

It was a common refrain among Oakland Italian Americans in years past: "See you at the club." It still is but not like the old days. Back then, a number of clubs and other organizations dotted Oakland's Italian American social landscape. They were athletic, fraternal, religious, and purely social in nature, and they provided a variety of activity for members. As times changed, interest and membership in many of these clubs diminished; some combined with others, many faded away.

Social clubs, more than other types of organizations—and more so, in many ways, than institutions such as church and school—characterized the history and heritage of Oakland's Italian American community. Three of them remain: the Colombo Club, the Fratellanza Club, and the Ligure Club. All began as men's clubs and remain so, although all have active women's auxiliaries and are open to a limited number of members of non-Italian descent. Immigrant men from respective regions of Italy formed the clubs. Founders of the Colombo and Fratellanza Clubs—the Colombo was named for Italian-born explorer Christopher Columbus and *fratellanza* means "fellowship" or "camaraderie"—were Piemontese, from the Piedmont region of northern Italy. Founders of the Ligure Club were Genovese and hailed from northern Italy's Liguria region. The oldest and largest of the clubs, with more than 900 members, is the Colombo Club, formed in 1920. The Fratellanza and Ligure clubs date to the 1930s.

Today the clubs retain much of the flavor and continue some of the events of the old days in Oakland, although without the same pace and intensity. Old-timers fondly remember weekly Saturday night dances with large bands and heavily attended family dinners served family style, festive holiday parties, and frequent summer picnics. They hope that club members today and in the future will maintain the old customs and traditions as well as revive the speaking of Italian and the appreciation of Italian culture at the clubs.

As legendary Colombo Club member Ed Basso puts it, "The young people are the ones who have to keep the tradition going."

They are working on it.

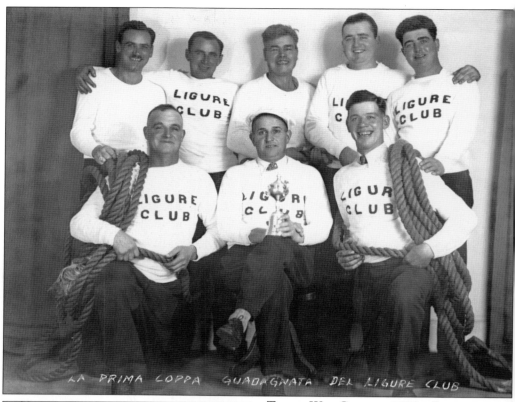

LA PRIMA COPPA GUADAGNATA DEL LIGURE CLUB

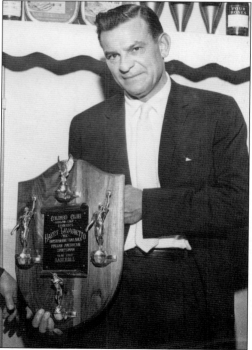

TUG OF WAR CHAMPS, 1930S. Few photographs exist from the old days of Oakland's Ligure Club, founded in 1934 by immigrant men from Italy's Liguria region. Here jubilant members mark their victory in a tug-of-war against other Italian American social clubs. Pictured are, from left to right, (seated) Giulio Biggi, Joe Mangini, and unidentified; (standing) Pete Valerino, Roy Ratto, unidentified, Mingo Perata, and unidentified. (Courtesy of Jess Giambroni.)

COOKIE COMES HOME, 1957. Baseball star Harry "Cookie" Lavagetto, a product of north Oakland's Italian American neighborhood, was honored by Oakland's Colombo Club as Outstanding Bay Area Italian American Sportsman. By this time, Cookie had ended his major league career with the Brooklyn Dodgers and turned to coaching, including a stint with the minor league Oakland Oaks. (Courtesy of the Colombo Club.)

ROCKY MARCIANO NIGHT, 1959.
The Colombo Club, Oakland's first and largest Italian American social club, had a gala dinner in honor of Italian American boxing champion Rocky Marciano. It was noisy as hundreds of members gathered to greet the champ. Leroy Casale, who attended the event, remembers Rocky booming out, "Hey, you guys—quiet down!" They did. (Courtesy of the Colombo Club.)

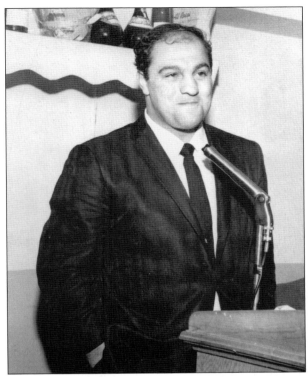

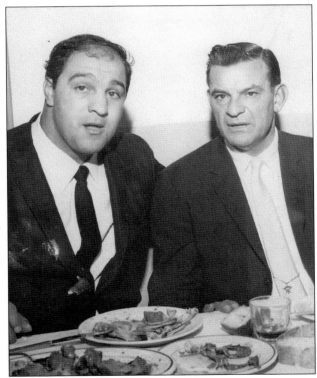

ROCKY AND COOKIE, 1959. Local Italian American hero Cookie Lavagetto (right) was a special guest at the Colombo Club's Rocky Marciano dinner. Born and raised in north Oakland, Lavagetto had a successful career in major league baseball and in later years coached the minor league Oakland Oaks. No one leaves hungry from a Colombo Club meal; the champ and Cookie were no exception. (Courtesy of the Colombo Club.)

BOCCE PLAYERS, 1960s. Bocce, a game that dates to Roman times, was a popular pastime among Italians, predominantly men, in the old days of Oakland's Italian American community. Casual matches and competitive league play took place on indoor and outdoor courts at social clubs, bars, and parks. Players used brass balls and courts, made of sand and crushed seashells, were carefully maintained. In these photographs, one gent rolls a ball in classic form and the other men are discussing the position of balls they rolled before tallying the score. These unidentified players mostly likely were members of Oakland's Fratellanza Club, the location of these particular courts. A league consisting of men and women of all ages from the Fratellanza and Ligure clubs uses the courts today. (Both courtesy of the Fratellanza Club archives.)

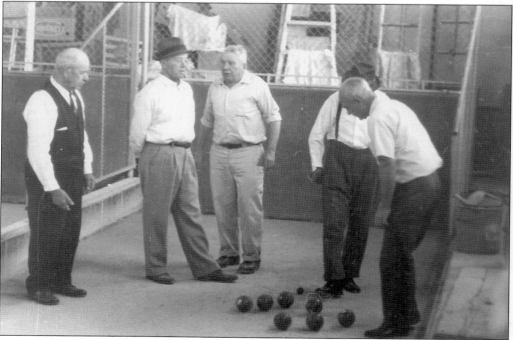

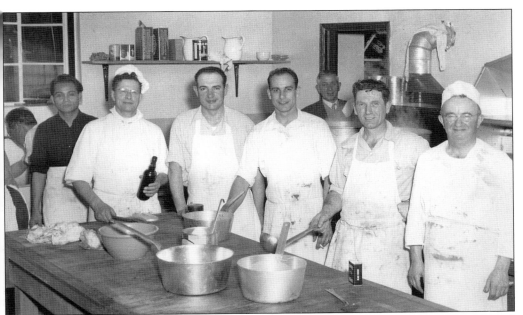

The Old Kitchen, 1949. Men traditionally did the cooking at Oakland's Italian American social clubs. This team is preparing an anniversary dinner to mark the founding of the Fratellanza Club; About 500 members and guests typically attend events such as this. Cooks are, from left to right, Marco "Mike" Ruggero, Mario Lovisone, John Penna, Art Grazano, and Bob Ferrarro. (Courtesy of the Fratellanza Club archives.)

New Kitchen, 2004. Chief cook Michele Gasparro (left) and helper Vince Lomanico show off the Fratellanza Club's remodeled kitchen. On the counter are marinated steaks. In the background are large pots used to make sauce and gravy. The "Frat" and other Italian American social clubs in Oakland traditionally have featured monthly men's birthday dinners attended by as many as 500 members and guests. (Courtesy of the Fratellanza Club archives.)

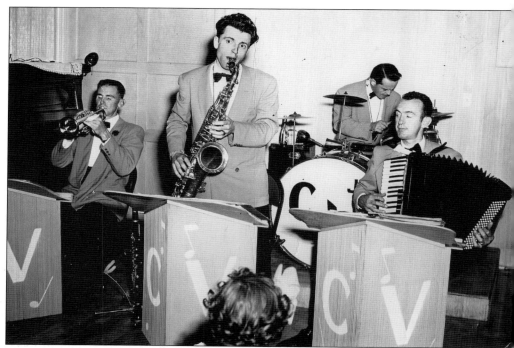

DANCE BAND, C. 1950. Bands like this one played often at dinner-dances, wedding receptions, and other events at Oakland's Italian American social clubs. In this group, bandleader Joe Carmass played drums and Carl Valpreda handled the accordion, an essential element of any Italian band of the day. (Courtesy of Elsie Giuntoli.)

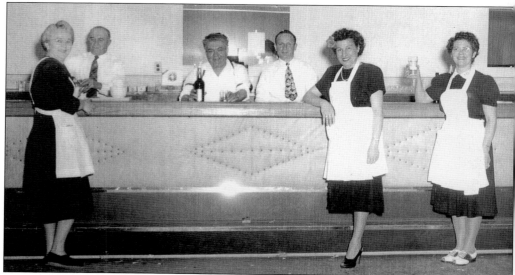

AT YOUR SERVICE, 1940s. Bartenders and waitresses prepare for an event at the Fratellanza Club. Behind the bar are, from left to right, Cesare Rivelli, Charlie Perata, and an unidentified bartender. Waitresses are, from left to right, Minnie DeSoto-Wright, Virginia Gale, and an unidentified waitress. Cooks, bartenders, and wait staff at Oakland's Italian American clubs typically were members who volunteered their services. (Courtesy of the Fratellanza Club archives.)

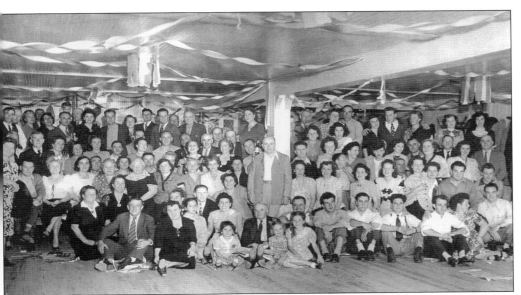

BON VOYAGE, 1947. A large crowd of well-wishers turned out at the Fratellanza Club to bid farewell to Victor "Tony" Sciacero (standing, center) before his trip to visit family and friends in Italy. He was one of the club's founders and an early president. Behind Tony, one reveler displays a bottle of celebratory champagne. (Courtesy of the Fratellanza Club archives.)

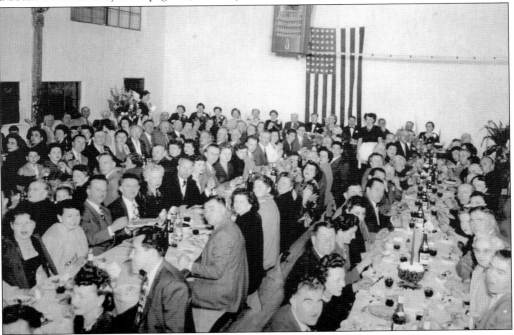

FRATELLANZA DINNER, 1940s. The large U.S. flag is a sign of Italian American patriotism at this Fratellanza Club dinner. The scene is typical of Italian American social club dinners, with members and guests seated at long tables and the meal served family style with plenty of wine. The head table at this event indicates it was a special event, possibly a club anniversary dinner. (Courtesy of the Fratellanza Club archives.)

THE FRATELLANZA CLUB, 1970. Founded in 1932 by 13 bachelors, most or many of whom were immigrants, the Fratellanza Club—the name means "fellowship" or "camaraderie"—built this headquarters building on Sixty-sixth Street in west Oakland in 1948. The first clubhouse was in the basement of a nearby home. In use today and looking much the same as it did in years past, the building houses a ballroom and lounge, each with bars, a dining hall, a large kitchen, and two indoor bocce alleys. The Fratellanza Club sign flashes with red, white, and green neon. The flagpole atop the building once stood at the old Oakland Oaks baseball park in nearby Emeryville. Club membership numbers about 500 men, 10 percent of whom, according to club bylaws, may be of non-Italian descent. (Both courtesy of the Fratellanza Club archives.)

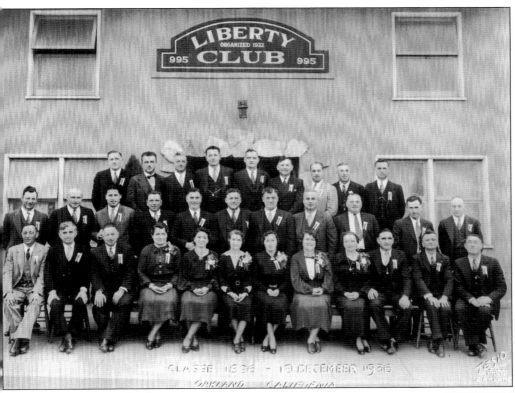

LIBERTY CLUB, 1930s. In the formative years of Oakland's Italian community, many social clubs developed, but most have since faded away. The Liberty Club, established in 1932, had its quarters on Forty-fourth Street in west Oakland, where this high school reunion took place. The club lasted until the 1960s, when it ended due to dwindling membership. (Courtesy of the Fratellanza Club archives.)

JOLTIN' JOE THE BARTENDER, 1940s. Yes, that is a young Joe DiMaggio of big league baseball fame. He was once a celebrity bartender at the Colombo Club, Oakland's largest Italian American social club. DiMaggio, who grew up in San Francisco's North Beach, was born of Italian immigrants in Martinez, a fishing village near Oakland. He had family and friends in the East Bay. (Courtesy of the Colombo Club.)

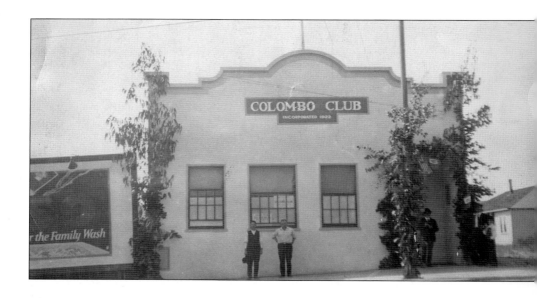

THE COLOMBO CLUB. Formed in 1920, the Colombo Club is Oakland's oldest and largest Italian American social club. Immigrant men from Italy's Piedmont region who worked at Oakland's Bilger Quarry established the club. At first they met at one of the men's homes to relax and socialize. By 1922, the club had purchased a small building for its headquarters at 4915 Broadway. It expanded to larger quarters in 1951 at 5321 Claremont Avenue, site of the current headquarters. The club has a membership of more than 900 men and a women's auxiliary of more than 200. Various events take place at the club, including dances, family dinners, and musical performances. The club's goals have remained constant—to promote the best interests of members, to sustain a sense of Italian American community, and to nurture the highest ideals of American citizenship. (Both courtesy of the Colombo Club.)

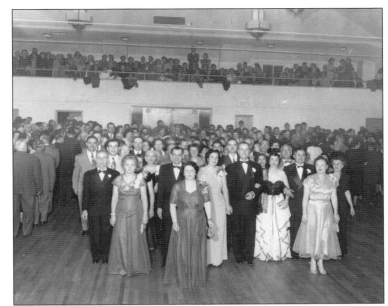

GRAND ENTRANCE, 1951. Formal attire was the order of the day at this Colombo Club procession known as the Grand Entrance. Led by club officials, members paraded into the club's brand new ballroom during the inauguration ceremony of the club's spacious new headquarters building on Claremont Avenue in Oakland. It was a heavily attended event, with members and guests crowding the mezzanine. (Courtesy of the Colombo Club.)

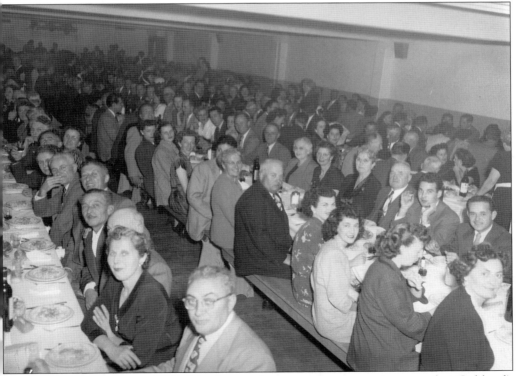

INAUGURATION BANQUET, 1951. Members and guests prepare to enjoy a meal at Oakland's Colombo Club in celebration of the opening of the club's new facilities. The dining room, in use today, accommodates about 500 people. The expanded headquarters building on Claremont Avenue also has a large ballroom with a bar and stage, lounges, a large kitchen, meeting rooms, and offices; it once included a bocce alley. (Courtesy of the Colombo Club.)

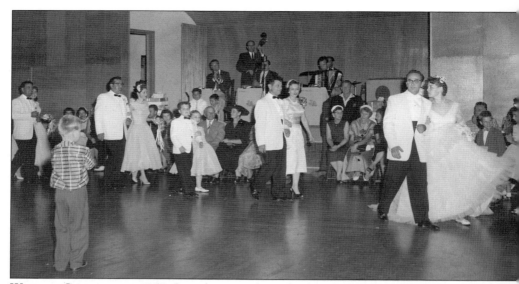

WEDDING CELEBRATION, 1957. Over the years, the Colombo Club has been the setting of numerous wedding receptions. An exceptional example celebrated the marriage of Manny and Marie Camara (above, far right). There were 900 guests, and the dinner required two seatings. Manny tossed his bride's garter from the mezzanine of the club's ballroom to a cluster of enthusiastic men below. Guests danced to a live orchestra in the club's spacious ballroom and dined in the lower-level banquet hall. In 2007, the Camaras celebrated their 50th anniversary in the same club facilities with 225 friends and family members in attendance, many of whom had attended the 1957 event. (Both courtesy of Marie and Manny Camara.)

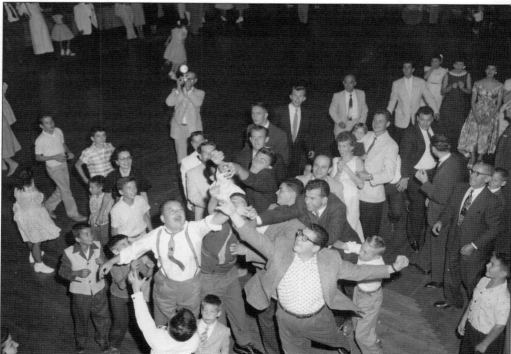

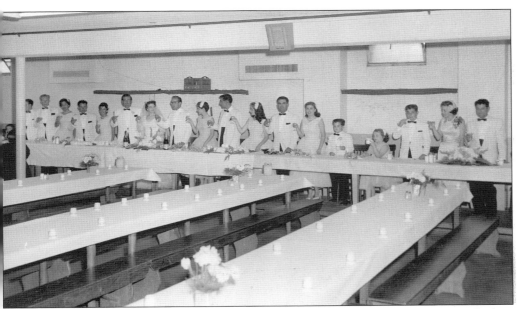

WEDDING TOAST, 1957. Bride and groom Marie and Manny Camara join in a toast with their large wedding party before quests arrive in the Colombo Club banquet hall. The popular Oakland club has been the scene of many receptions, but the Camara event was perhaps the largest—a whopping 900 guests turned out, so many that the meal was served in two sittings. (Courtesy of Marie and Manny Camara.)

HAPPY AT THE FRAT, 1990. With its festive neon sign, Oakland's Fratellanza Club, known as "the Frat," has been the reception site for weddings of many members and their children. Inside, the club has a large ballroom with bar, a banquet hall, and two bocce alleys. Celebrating their marriage here are Dan and Karen Raven; she is the daughter of Fratellanza member John Bozzone. (Courtesy of the Fratellanza Club archives.)

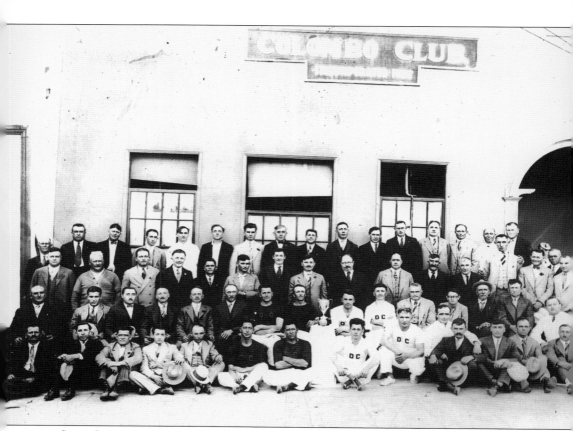

STILL GOING STRONG, 1920s. The Colombo Club, Oakland's oldest and largest Italian American social club, in 2010 celebrated the 90th anniversary of its founding. Formed by immigrant men from northern Italy's Piedmont region, who named the club after Italian-born explorer Christopher Columbus, the club used this building on upper Broadway as its first headquarters. This group includes founders of the club and early members. From the start, it has been mainly a social club, with a women's auxiliary established later. It was a center of activity for Oakland's Italian American community and sponsored numerous civic events. Like other Italian American organizations in Oakland, it provided a setting for socializing, celebrating special events, and maintaining cultural customs and traditions as Italian Americans blended into the mainstream of life in Oakland and the East Bay. Significant in this vintage photograph are the men dressed in team jerseys. They were Colombo Club *pallone* players, a blend of handball and rugby played with a hard ball and wooden mitts. Pallone has ancient roots in Italy and is no longer played in Oakland. (Courtesy of the Colombo Club.)

Seven

BALL PLAYERS AND OTHER NOTABLES

Italian Americans in Oakland have achieved success in all walks of life. For the generation that came of age during the formative years of Oakland's Italian American community, two particular areas of achievement were baseball and public service. For example, Felix Chialvo and Fred Maggiora served on the Oakland City Council, and Emanuel P. Razeto was a county supervisor. As for baseball players, in both the minor and major leagues, Italian Americans were hometown heroes, providing entertainment and inspiration to children and adults alike.

Why did Italian Americans of the era gravitate to playing baseball? Local historian (and baseball fan) Ray Raineri, himself a product of Oakland's Italian American community, theorizes it was because they were built for the game—tough and scrappy, not, as a rule, big or tall. It was also a way to make or supplement an income.

Two Oakland natives who made it to the big leagues were Harry "Cookie" Lavagetto and Ernie Lombardi, both the sons of Italian immigrants. Billy Martin, a Berkeley native whose mother was of Italian descent, scored big as manager of the New York Yankees and the Oakland Athletics. And Joe DiMaggio of New York Yankee fame grew up and played minor league ball in San Francisco but was born of Italian immigrant parents in Martinez, on the Oakland side of San Francisco Bay, and was a visitor to Oakland's Italian American community.

The hometown team was the Oakland Oaks of the long-gone Pacific Coast League. A number of Italian Americans played for the Oaks, notably the Raimondi brothers—Billy, Ernie, and Al—sons of an immigrant bootblack who were described by the *Oakland Tribune* as "west Oakland's first baseball family."

The Oaks delighted fans and won five championships during their decades in Oakland. The Oaks left Oakland in the 1950s when interest in minor league baseball was waning. The team played its final season at the colorful Oaks Ball Park in Emeryville in 1955, prompting Raineri to write in a 2010 article, "This symbolized the passing of an era rich in local baseball tradition and history"—and, it could be added, rich in Oakland Italian American history.

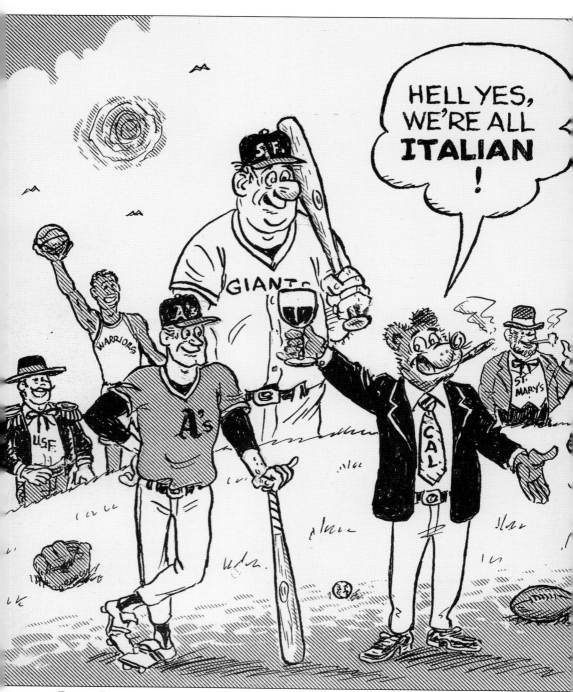

PRIZED POSSESSION, C. 1980. Lee Susman, noted sports cartoonist for the *Oakland Tribune* in its glory days, is a good friend of Oakland's Italian American community. He created this illustration especially for the Colombo Club to celebrate its association with the Bay Area sports scene. Susman has attended many events at the club, Oakland's oldest and largest Italian American social club. The drawing, in Susman's classic style, depicts the Bay Area's collegiate and professional sports

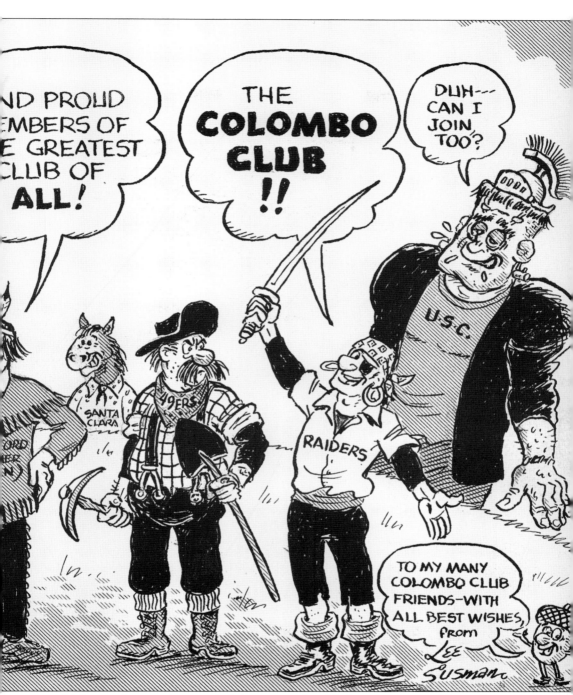

teams, which over the years have included numerous local Italian American athletes. Susman's signature and a special message appear at the bottom right, along with the "little acorn" figure that served as his trademark. This one-of-a-kind piece of art has a place of honor above the Colombo Club bar. (Courtesy of Lee Susman and the Colombo Club.)

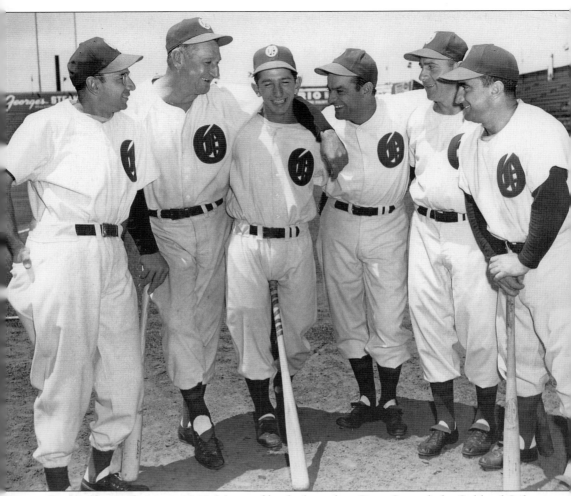

PACIFIC COAST CHAMPS, 1948. Managed by the legendary Casey Stengel, the Oakland Oaks won the Pacific Coast League Championship in 1948 for the first time since 1927. Dubbed the "Nine Old Men," the team consisted mostly of veteran players. In the center of this rare photograph is a young Billy Martin, a native of Berkeley whose mother was of Italian descent. Flanking him, all sons of Italian immigrants, are (from left to right) Billy Raimondi, a star Oaks catcher who grew up in Oakland; Ernie Lombardi, an Oakland native who started his career with Oaks and went on to fame as a catcher with the Cincinnati Reds; Harry "Cookie" Lavagetto, another Oakland native who broke in with the Oaks and became a star third baseman for the Brooklyn Dodgers; Les Scarsella, a first baseman and East Bay native who spent five years in the major leagues; and second baseman Dario Lodigiani, who was born in San Francisco, played early in his career with the Oaks, and later with the Philadelphia Athletics and Chicago White Sox. (Courtesy of Diane Lodigiani.)

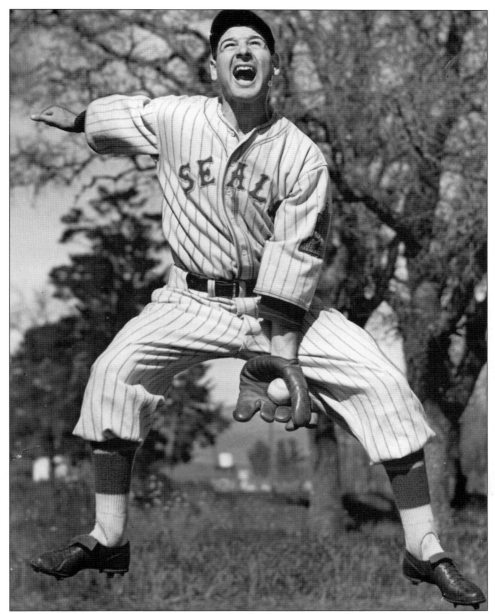

ERNIE RAIMONDI, 1939. John and Josephine Raimondi were Italian immigrants who lived in west Oakland and had seven children. Three sons—Billy, Ernie, and Al—were popular baseball players for the Oakland Oaks of the Pacific Coast League. Their father, a bootblack, was killed by a hit-and-run driver, leaving his wife to raise the family. Ernie (above) was a promising third baseman who had his career cut short when he was drafted into the U.S. Army in 1944 during World War II. He was killed in action a year later in France. This photograph captures Ernie in animated and exuberant form during a tryout with the San Francisco Seals, an across-the-bay rival of the Oaks in the Pacific Coast League. The City of Oakland dedicated a park in Ernie's memory in his old west Oakland neighborhood. In use today, it includes a baseball field and playground. (Courtesy of the *Oakland Tribune*.)

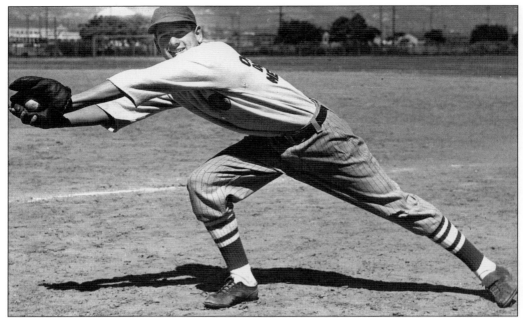

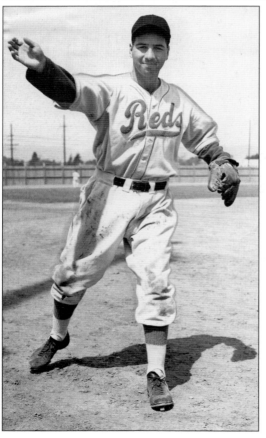

RAIMONDI BROTHERS, 1930s. The *Oakland Tribune* once referred to the Raimondi bothers as "West Oakland's first baseball family." Together with brother Billy, Ernie and Al Raimondi played for their hometown Oakland Oaks and other teams in the Pacific Coast League. Shown above with his classic stretch and smile is Ernie Raimondi when he played third base in Oakland's Downtown Merchants Association league. Al (left) had an active career as a pitcher for several minor league teams from 1937 to 1950. He is shown here during his time with the Mission Reds of the Pacific Coast League. (Both courtesy of the *Oakland Tribune*.)

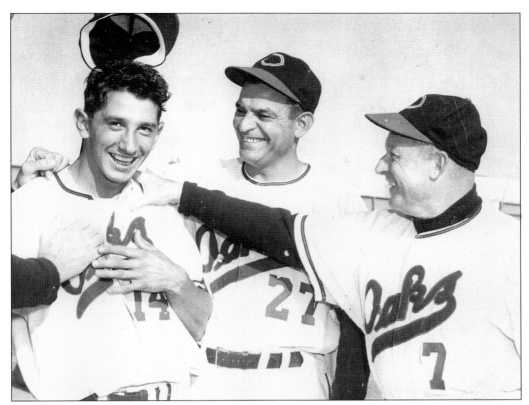

BILLY MARTIN, 1949. Known for his flamboyant management of the New York Yankees and Oakland Athletics, Billy Martin got his start in baseball as a second baseman with the Oakland Oaks. He is pictured here with teammate Harry "Cookie" Lavagetto (center), an Oakland native, and Oaks Manager Charlie Dressen. Martin was born in Berkeley; his mother was of Italian descent. (Courtesy of the *Oakland Tribune*.)

BILLY MARTIN AND MOM, 1980. Billy Martin managed the Oakland Athletics in the early 1980s, leading the team to an American League West Division title in 1981. In this photograph, he poses with his mother, Joan Downey, at the opening game of the A's 1980 season. Martin died in 1989 in an automobile accident near his home in upstate New York. (Photograph by Ron Riesterer; courtesy of the *Oakland Tribune*.)

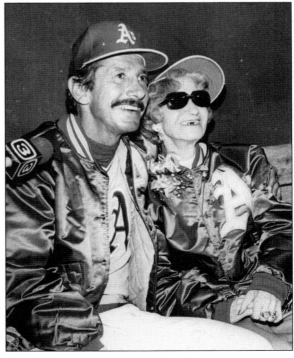

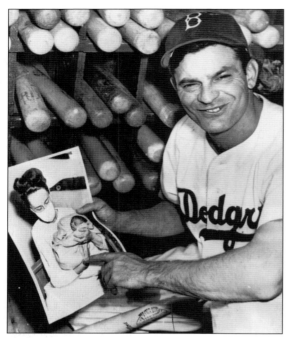

COOKIE'S BIG WIN, 1947. Harry "Cookie" Lavagetto gives a big smile in the Brooklyn Dodgers' clubhouse upon seeing an *Oakland Tribune* photograph of wife Mary and newborn son Harry Michael. The photograph was taken the day Lavagetto cracked a game-winning hit in a World Series encounter between the Dodgers and the New York Yankees. It became known as "The Cookie Game." (Courtesy of the *Oakland Tribune*.)

HOMETOWN HERO, 1954. An Oakland native who lived in the predominantly Italian American Temescal neighborhood, Harry "Cookie" Lavagetto was a special hero to youngsters of the time. He was nicknamed Cookie after Victor "Cookie" DeVincenzi, president of the Oakland Oaks, who gave Lavagetto his start in professional baseball. Lavagetto, a third baseman, played many years in the major leagues, returning to the Oaks in 1948. (Courtesy of the *Oakland Tribune*.)

Young Joltin' Joe, 1934. A young Joe DiMaggio (right) poses with San Francisco Seals teammates Ernie Sulik (left) and Mike Hunt. DiMaggio, who would achieve superstardom with the New York Yankees, grew up in San Francisco but was born in Martinez, near Oakland, to Italian immigrants parents. He had friends and relatives in Oakland and the East Bay and sometimes attended social events in the area. (Courtesy of the Colombo Club.)

Oakland Oaks Pals, 1948. Dario Lodigiani (left) and Les Scarsella take a breather in the Oakland Oaks clubhouse. The sons of Italian immigrants, they were members of the Oaks' "Nine Old Men" team that was managed by Casey Stengel and won the Pacific Coast League championship in 1948. Lodigiani was a close friend of Joe DiMaggio, and in high school, they were double-play partners. (Courtesy of Diane Lodigiani.)

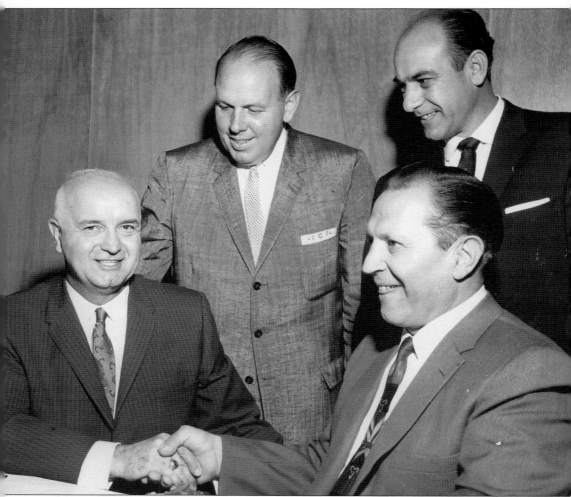

ITALIAN CIVIC LEADERS, C. 1960. Many Italian Americans contributed to the greater Oakland and East Bay community through public service and as business leaders. Shaking hands during this celebratory moment are Alameda County supervisor Emanuel P. Razeto (front left), who represented north Oakland, and Oakland Bank of America executive Leo Ostaggi. Looking on are Felix Chialvo (back left), who served for many years on the Oakland City Council, and John Penna, an Oakland business leader and a past president of the Colombo Club. It was Razeto, a native of Genoa, Italy, who suggested in 1969, according to an *Oakland Tribune* report, that the newly constructed Grove Shafter Freeway should have been named after a distinguished Italian American because it cut through a part of Oakland's largely Italian American community. "America was named after an Italian," Razeto was quoted as saying. (Courtesy of John Penna.)

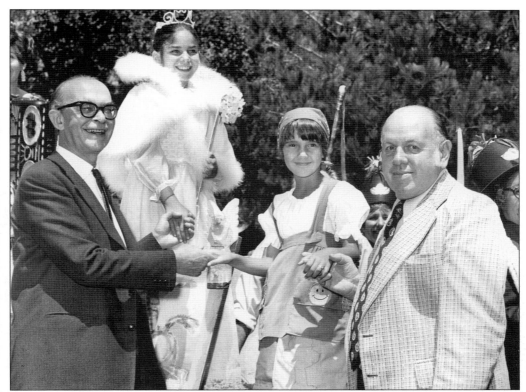

ITALIAN VISITORS, 1975. Oakland's Italian American community attracted visiting dignitaries and celebrities over the years. One distinguished visitor to an Italian festival at Children's Fairyland in Oakland was Dr. Paolo Emilio Mussa (left), the Italian consul general based in San Francisco. With him (from left to right) are Fairyland Princess Lisa Pegueros; Francesca Raimondi, a representative from Rome; and Oakland City Councilman Felix Chialvo. (Courtesy of the *Oakland Tribune*.)

OFFICIAL GREETINGS, 1960. Fred Maggiora was another Italian American who, with Felix Chialvo, served for many years on the Oakland City Council. In this photograph, as acting mayor he presents an official letter of greeting to three goodwill ambassadors from Puerto Rico. Maggiora was standing in for Mayor Clifford E. Rishell. (Courtesy of the *Oakland Tribune*.)

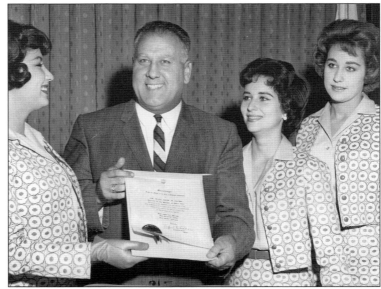

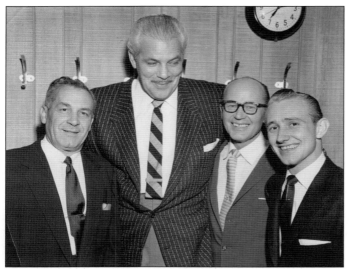

PRIZEFIGHTER PAYS A VISIT, 1950s. Prizefighter and actor Max Baer towers over Angelo "Nick" Bianchi (left), Joe Gershick (middle right), and an unidentified companion. Bianchi was a north Oakland resident who operated Oakland's Sonoma Wine Company. He and Gershick owned Tim's, a popular cocktail lounge and restaurant in Alameda across the estuary from Oakland. Baer lived in the East Bay and frequented Tim's. (Courtesy of the Bianchi family.)

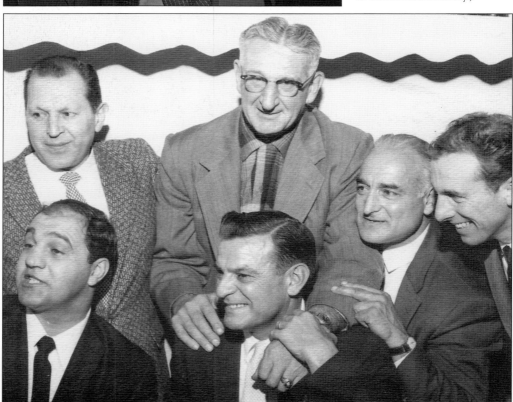

THREE SPORTS LEGENDS, 1959. Italian American heavyweight boxing champion Rocky Marciano (first row, left) visited Oakland's Colombo Club for a dinner in his honor. With him in this photograph are two members of Oakland's Italian American community who had illustrious careers as major league baseball players—Harry "Cookie" Lavagetto (first row, center) and Ernie "Bock" Lombardi (second row, center). Also shown are Chris Rivelli (second row, far left), Niggy Silva (second row, third from left), and Bill Laws (far right). (Courtesy of the Colombo Club.)

FEDERATION QUEEN, 1970.
Margaret Krause begins her reign as Columbus Day queen representing the Italian American Federation of the Easy Bay. Felix Chialvo, a longtime member of the Oakland City Council and a native of the city's Italian American community, was master of ceremonies for the event. (Photography by Prentice Brooks; courtesy of the *Oakland Tribune*.)

SUPER BOWL CHAMPS, 1977. Italian American John Vella (far right) was a key member of the Oakland Raiders during the team's glory years, including its Super Bowl XI victory in 1977. An offensive tackle, Vella is pictured here with famed Raider coach John Madden and teammate Art Shell. Vella lives in the Oakland area and operates Vella's Locker Room, which sells Raiders gear and memorabilia. (Courtesy of John Vella.)

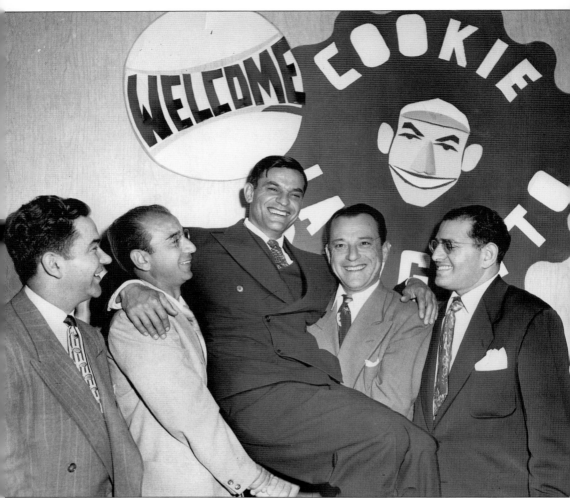

WINING AND DINING, 1950s. Notable in this photograph is the appearance of Oakland's Billy Raimondi (second from left). He was a popular star catcher with the Oakland Oaks minor league baseball team of the old Pacific Coast League and for a time managed the beloved team. His brothers Ernie and Al also played for the Oaks. This was a tribute event at Oscar's restaurant in Oakland for another hometown baseball hero, Harry "Cookie" Lavagetto, a product of Oakland's Italian American Temescal district who played for the Oaks, achieved big-league fame, and returned to coach the Oaks. Also shown here are Oscar's owner Johnny Souza (far left), Oakland businessmen Johnny Vergez (second from right), and Abe Rose (far right). (Photograph by Lonnie Wilson; courtesy of the *Oakland Tribune*.)

Eight

La Bella Vita

Italians in the United States have endured their share of adversity. Both as immigrants and native-born citizens, they have known the brunt of poverty and struggle, discrimination, prejudice, ethnic slurs, and stereotyping of various forms. In Oakland and elsewhere, they have nonetheless thrived and contributed to the betterment of their community, state, and nation as a whole. They have also displayed a vitality, sense of humor, and zest for life that, in Italian, can be characterized as *la bella vita*, or "the good life."

For Italian Americans in Oakland and the East Bay, good times played out in a number of ways. A main event through the 1990s was the Italian Festa, a colorful weekend festival organized by a federation of social and cultural organizations as a way to celebrate and share their Italian heritage. Other events with an Italian flavor over the years have included group picnics, Columbus Day parades and queen competitions, musical performances, and good times in general—within families, as part of Oakland's once-active nightlife scene, or at Oakland's three remaining Italian American social clubs. Oakland Italian Americans even had a favorite destination in northern California, within 100 miles of home, for family vacations and weekend getaways. Resorts there, one of them built by a Genovese immigrant who worked as an Oakland scavenger, catered to a largely Italian clientele, and a couple still do so.

In more recent years, as a way to keep the legacy alive, Oakland's three Italian American social clubs—the Colombo, Fratellanza, and Ligure Clubs—have organized an old-fashioned picnic with traditional food, accordion music, games from the old days, and dancing outdoors. "Come early with your family and friends," the picnic flier urges, "and enjoy a delightful day the Italian way!"

THE ITALIAN–AMERICAN FEDERATION OF THE EAST BAY & THE PORT OF OAKLAND PRESENT

Italian Festa '98

**SATURDAY,
SEPTEMBER 19
11 AM – 10 PM**

&

**SUNDAY,
SEPTEMBER 20
10 AM – 4 PM**

**FREE ADMISSION •
AUTHENTIC ITALIAN
FOOD • ARTS & CRAFTS
FAIR • KIDS' ACTIVITIES
LIVE ENTERTAINMENT
AND MORE!**

*Sponsored by:
Continental Volvo, TCI,
Dreyer's, Port of Oakland,
KPIX Channel 5, Budweiser,
Trendwest, Shell Development
Group, and Gallo Salame.*

Jack London Square

VISITORS ARE ENCOURAGED TO TAKE PUBLIC TRANSPORTATION TO THIS EVENT • RIDE THE ALAMEDA/OAKLAND FERRY FROM S.F. AND ALAMEDA • LIMITED $5 EVENT PARKING IS AVAILABLE IN THE ALICE STREET LOT • FOR MORE INFORMATION, CALL THE JACK LONDON SQUARE EVENTS HOTLINE AT (510) 814-6000 • JACK LONDON SQUARE IS LOCATED AT THE FOOT OF BROADWAY IN OAKLAND.

ITALIAN FESTA, 1990s. A landmark event in the history of the Oakland and East Bay Italian American community was a weekend festival, or *festa*, that took place annually for 10 years at Jack London Square along Oakland's waterfront. Organized by a coalition of Italian American social and cultural organizations, the festa attracted large crowds and featured Italian food booths and a variety of displays, performances, exhibits, and demonstrations. New to the festa in 2001 were a pasta sauce competition, grape stomping, gondola rides, a display of classic Fiat cars, and a bocce ball demonstration. It was a colorful, entertaining, and informative way for Italian Americans to celebrate their heritage and revive the atmosphere and feeling that once distinguished Oakland's Italian American community. To the disappointment of many, the festa ended in 2001 due mainly to cost and administrative issues. That year's festa happened only days after the 9/11 attack, which added a somber tone and a sense of intensified patriotism to the event. (Courtesy of the Fratellanza Club archives.)

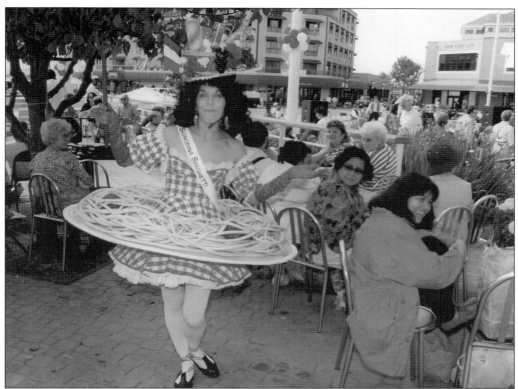

SIGNORINA SPAGHETTI, 1998.
One of the strolling attractions
at Oakland's Italian Festa was
"Miss Spaghetti," who is otherwise
unidentified in this photograph.
Along with other performers, she
would prance and twirl among festa
attendees with her colorful and
highly decorated costume, complete
with large serving fork. (Courtesy
of the Fratellanza Club archives.)

ROARING TWENTIES PERFORMER, 1925.
Another performer in colorful garb,
though not as extreme as Signorina
Spaghetti and from a different era, was
Margaret Nurra DeVecchio. A member
of Oakland's DeNurra family, longtime
residents of the Temescal district,
Margaret was an adventurous young
woman for her time. She performed
with the Oliver Players, a dance
troupe in San Francisco during the
rollicking Roaring Twenties. (Courtesy
of Al and Deanna DeNurra.)

COLUMBUS QUEEN AND PRINCESSES, 2000. Dating to the 1930s, Italian American clubs of Oakland and the East Bay have participated in a competition to select young women to serve as queen and princesses for the celebration of Columbus Day. At the 2000 Italian Festa in Oakland, Queen Antoinette Cannaday (right, with sash) and her princesses greet the crowd. (Courtesy of Al and Deanna DeNurra.)

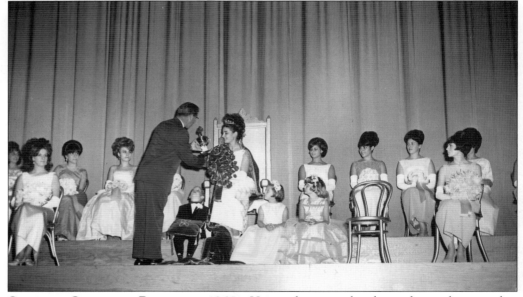

COLUMBUS QUEEN AND PRINCESSES, 1960s. Hair and gown styles changed over the years, but the celebration of Columbus Day by choosing a queen and her princesses has remained constant for Oakland's Italian American community. This photograph shows the crowning of the queen and her court in the ballroom of Oakland's Fratellanza Club. (Courtesy of the Fratellanza Club archives.)

MANGIA, MANGIA, 1990s. Fried calamari and shrimp cocktail were the inviting offerings at this Italian Festa food stand staffed by happy members of Oakland's Ligure and Fratellanza Clubs. From left to right are Joe Favilli, Brian Ponzini, Al Christiani, Art Parziale, and Lorenzo Tinnarello. (Courtesy of the Fratellanza Club archives.)

MUSIC FOR THE FESTA, 1990s. No Italian party, picnic, or other social gathering would be complete without accordion music. In this scene from one of the annual Italian Festa events staged by the Italian American Federation of the East Bay, no fewer than five accordion players join to entertain the crowd. The Italian Festa took place at Oakland's Jack London Square. (Courtesy of the Fratellanza Club archives.)

SAN FRANCISCO, 1990s. Members of the East Bay's Italian American community have played a role over the years in Columbus Day festivities across the bay in San Francisco. Here Columbus Day queen Marisa Pino (left) and Monica DeNurra, representing the Italian American community of Oakland and the East Bay, wave to the crowd as their classic carriage passes Sts. Peter and Paul Church during San Francisco's Columbus Day parade of 1999. In the photograph below, enthusiastic revelers from the Italian American Federation of the East Bay join the Columbus Day parade in their flatbed truck. Waving at the far left are Al and Deanna DeNurra. The parade has been a mainstay of San Francisco Columbus Day festivities, now called Italian Heritage Day, for many decades. (Left, courtesy of the Colombo Club; below, courtesy of Al and Deanna DeNurra.)

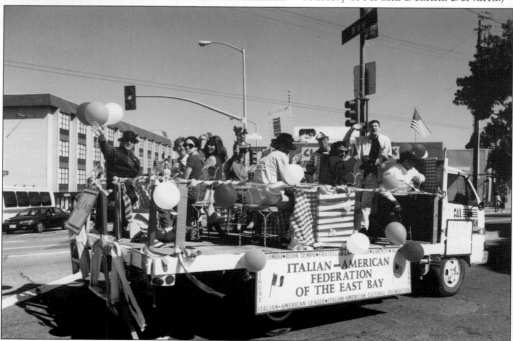

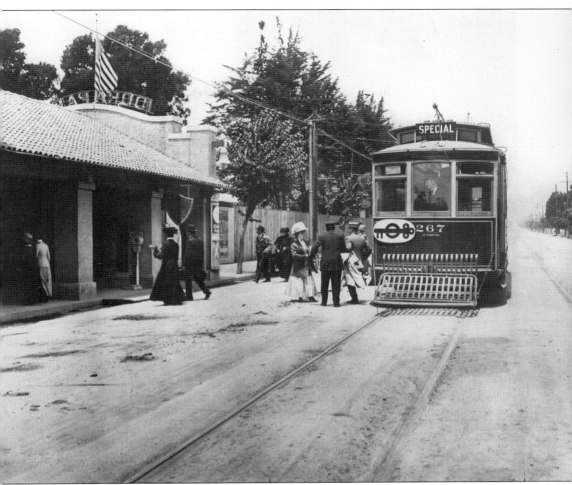

OAKLAND'S CONEY ISLAND, 1915. Idora Park, a 17-acre amusement complex known as the "Coney Island of the West," was a popular destination for Oakland residents, including Italian immigrants who at this time were settling in the Temescal neighborhood. In this photograph, a Key Route trolley lets out passengers at the park entrance on Telegraph Avenue near Fifty-seventh Street. Admission to Idora Park was 10¢ and it was open 30 weeks a year. The walled-in park was famous for its Opera House, and after the 1906 San Francisco earthquake and fire, comic stars from the Tivoli Theater relocated to Oakland and renamed themselves the Idora Park Comic Opera Company. Also after the earthquake, hundreds of displaced people, most likely including Italian immigrants, came to Oakland and camped at Idora Park. The park's many thrill rides cost 5¢ and were billed as "the largest" and "the first." The park's popularity declined with the advent of the automobile and was razed in 1929, giving way to residential development. (Courtesy of Ray Raineri.)

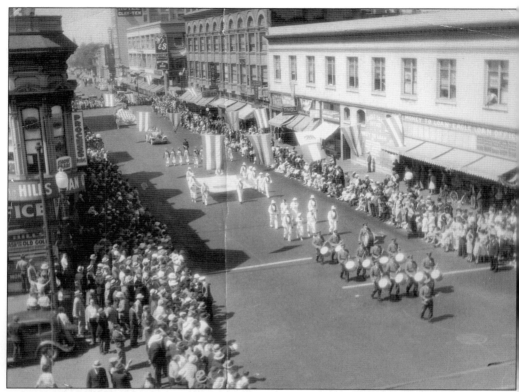

DOWNTOWN PARADE, 1930s. Parades were a popular attraction for residents of early Oakland, including Italian American residents. Bands, marchers, and drill teams representing Oakland's many Italian American social and cultural organizations participated in the parades, which celebrated national holidays and other major events. This parade took place in the area of Clay and Tenth Streets, near Oakland City Hall. (Courtesy of John Penna.)

MONTEREY CONVENTION, 1936. Members of Oakland Branch 40 of the Italian Catholic Federation ventured south to Monterey, California, to attend a statewide convention. The federation band gathered outside this Mission style building, probably in preparation for a parade to mark the occasion. Branch 40 also had a girls drill team. The branch was based at Sacred Heart Church in north Oakland. (Courtesy of Angie Rainero.)

BUILDING A LEGACY, 1940s. Giulio and Maria Biggi are shown here at Biggi's resort in Lake County, north of Oakland, in front of a towering stone fountain Giulio built by hand. His story, recounted by his son Dino, is one of Italian-immigrant ingenuity and determination—and the result has been a source of enjoyment and recreation for many Bay Area Italian Americans. Giulio immigrated to Oakland from northern Italy's Liguria region in 1931. He worked tirelessly as a scavenger, built a home in Oakland for his family, and then built a resort in Lake County where Italian Americans would go to spend time in the woods. Working by hand, he built cabins, halls for dancing and dining, and bocce courts. He built this fountain and fishpond with rocks he carried from a nearby river. Biggi's Family Resort was a favorite vacation spot for Italian Americans from Oakland and elsewhere in the San Francisco Bay Area for many years and is remembered fondly today for the good times it provided to young and old alike. (Courtesy of Dino Biggi and Bonnie Cunha.)

BIGGI'S FAMILY RESORT, 1950S. These are scenes of the resort Giulio Biggi built amid the pine trees in the Cobb Mountain area of Lake County, California. About 100 miles from San Francisco and Oakland, the resort provided fun and relaxation away from the bustle of city life for many Italian Americans over the years. Rates were reasonable at Biggi's, and activities were plentiful. They included hiking, swimming, hunting, fishing, a variety of games, and family-style meals. Biggi's was promoted as being in "the heart of mountain vacation area." Oakland Italian Americans were drawn to the area because of its proximity to the Bay Area, its natural beauty, abundant opportunity for recreation, the temperate weather, and the good company and camaraderie. For Italian immigrants, "it reminded them of being in the old country," says Giulio's son Dino. Resorts in the area continue to attract guests of Italian descent. (Both courtesy of Dino Biggi and Bonnie Cunha.)

ON THE TOWN, 1946. Downtown Oakland was a center of nightlife in the big band era of the 1940s. Restaurants, cocktail lounges, and dance clubs were alive with activity. One of the main supper clubs was Don Santo's French Quarter on Franklin Street. It was common then for guests at tables and booths to pose for the club's roving photographer. They would save the photographs with their stylized covers as souvenirs. The Bianchi family of Oakland saved many of these. Tillie Bianchi (second from left) and her husband, Angelo (third from right), are shown in this photograph with friends. Bianchi ran a winery in north Oakland's Italian American neighborhood and a popular restaurant and cocktail lounge in nearby Alameda. (Both courtesy of the Bianchi family.)

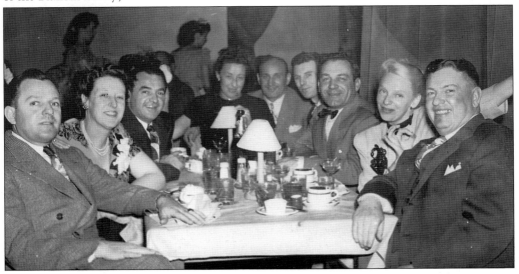

OMAR - 2086 BROADWAY - OAKLAND 12, CALIFORNIA

OAKLAND HOT SPOT, 1945. Especially notable in this supper club photograph is the appearance, according to Les Bianchi, of actor Humphrey Bogart (standing, far left in last row). Among the signatures on the back cover is "Humphrey Bogart." In the front row is Les's grandmother, Tillie. Omar, which was on Broadway in downtown Oakland—"Where the Elite Meet to Eat," as the card says—was one of many nightspots in downtown Oakland in the 1940s. The area attracted many big bands of the day and was known for its many ballrooms, one of which, in the style of Omar, was the Ali Baba Ballroom. All of them, along with others in the Jack London Square area at the foot of Broadway, have long been closed. (Both courtesy of the Bianchi family.)

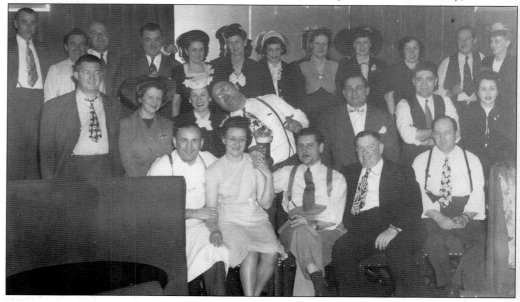

MOUNTAIN RESORT, 1930s. This is an excellent example of mealtime at one of the several resorts in northern California frequented by Italian Americans of Oakland and the San Francisco Bay Area in past decades. Hoberg's Resort, and similar resorts in pine-studded Lake County, offered lodging with meals at moderate rates and provided a wide array of activities for families, including hiking, swimming, boating, hunting, fishing, and dancing. The area was within 100 miles of the Bay Area. This group of diners awaiting their bowls of soup includes Yvonne and Gene Mencarelli (first and second from left) and Angelo "Nick" Bianchi (third from right), of Oakland. (Both courtesy of the Bianchi family.)

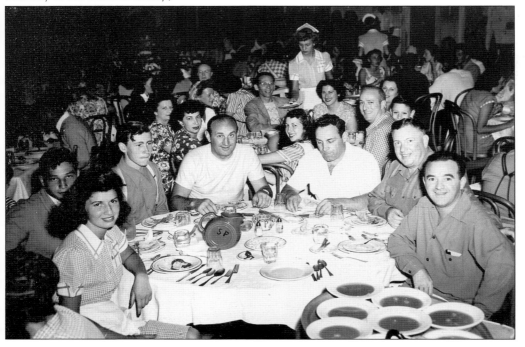

HUGS FOR THE COOK, 1980. Virginia Gale, whose maiden name was Fornaca, gets hugs from admirers as she prepares a crab dinner at the Ensign Club in Oakland. Virginia and her mother Fermina, were well-known, and obviously well liked, for their cooking skills and their participation in a number of Oakland Italian American organizations. The Ensign Club, once housed at Piedmont Avenue and Broadway, was formed by a group of Italian American men from Oakland who served in the U.S. Navy during World War II. "My mother and grandmother loved working at the club," says Karen Garcia, "and all the guys loved them." (Both courtesy of Karen Garcia.)

GOOD TIMES ON BROADWAY, C. 1945. These four pals from north Oakland's Italian American neighborhood, with their high-stop jeans, take a nighttime stroll along Broadway in downtown Oakland. They are, from left to right, Joe Biggi, Dino Biggi, Emil Firpo, and Herman Muzio. "For a couple of bucks," remembers Dino, amateur photographers on Broadway would snap pictures. (Courtesy of Dino Biggi and Bonnie Cunha.)

BARTENDER BUDDIES, 2006. Despite the outfits, these are not three monks and a dude. They are bartenders at Oakland's Fratellanza Club, and they are serving members and guests at an annual Halloween party. They are, from left to right, Bruno Andrina, Ralph Brignone, Rich Giaramita, and Rick Malaspina. The "Frat," one of Oakland's three Italian American social clubs, is the site of many festive events, including holiday parties and dinner-dances. (Courtesy of Gianfranco Sciacero.)

Rolling to Victory, 1976. This photograph, which appeared in the *Oakland Tribune*, is significant for several reasons. Mario Simonetti, who is rolling the bocce ball, and his partner, John Zanotto, were Oakland residents representing two generations of Italian American immigrants from two stages of immigration to the United States. Mario was from the Genoa area and John from the Venice area. They belonged to Oakland's Ligure Club, whose headquarters building, no longer in use, had three bocce courts. These two friends, joined by their love of the game and the fellowship of the club, were excellent bocce players and had won championships in competition with other Italian American social clubs. John's daughter, Elma Casale, has held onto his bocce trophies. Bocce continues to be enjoyed by young and old alike, women as well as men, in Oakland's Italian American community. (Photograph by Roy Williams; courtesy of the *Oakland Tribune*.)

LOCAL LEXICONS
AND PROVERBS

As they approached their 90s, two pals from Oakland's old Italian American community joined in on a special project. Ray Mellana and Ed Basso were born and grew up in the Temescal neighborhood of north Oakland. Ray became a lawyer and civic leader in the area, Ed a Bank of America manager. Ray was already writing his memoirs, prodded by his son John, a history teacher, when Ray's daughter Linda, a retired English teacher, encouraged him to include in his recollections a sampling of the Italian dialect spoken in the Italian Oakland of Ray's youth. He reached out to Ed, with his ironclad memory, and the result is what Ray titled, "A Piemontese Lexicon: The Words of My Youth." It became part of Ray's memoirs, which he shares with family and friends.

Like other Italian dialects—and they were and are numerous—the one spoken in the Piedmont region of northern Italy, where many immigrants to Oakland originated, is a rustic and quirky, even humorous, rendition of the Italian language. In old Oakland, dialect was a primary means of communication, especially since many people had come directly from Italy.

"The Piemontese dialect was my first means of communication within the family," Ray remembers. "And I continued to speak it into kindergarten."

Other Oakland Italians from other areas of Italy—Genoa, Tuscany, Venice, and southern Italy, for example—spoke their own dialects. To communicate with each other, they would mix different dialects, add some English, and come up with what amounted to a new, and now virtually lost, language.

Angie Rainero, another true "Temescalian," calls that other language "North Beach Italian," referring to the Italian district of San Francisco. An amalgam of regional dialect and newfound English, it created whole new words, with no resemblance to formal Italian. For example, *lo storo* meant "the store," and *il floro* meant "the floor."

"We all grew up speaking Italian, but most of us spoke the dialect of our parents, and the true, pure Italian language got lost along the way," Angie says.

The following pages contain portions of Ray and Ed's "Piemontese Lexicon" and Angie's "North Beach Italian."

Ray Mellana's Pronunciation Guide

To pronounce the following words and phrases as they are meant to sound, remember that "c" before "a," "o," and "u," and before consonants has a sound similar to the English "k." Before "e" and "i," the "c" has a sound similar to the English "ch," as in "church." Also be sure to emphasize the broad "a" and roll those "r's."

Here are examples of Piemontese dialect and North Beach Italian followed by translations and formal Italian.

Andooma: Let's go. *Andiamo.*
Andooma, stooma, o cosa fooma?: Are we going, staying, or what are we doing? *Andiamo, stiamo o che cosa facciamo?*
Balloordo: Dizzy, groggy, lightheaded. *Balordo.*
Ballong: A play ball. *Pallone.*
Boojah nang: Don't move. *Non muovere.*
Scapooma: Let's run, escape, or "scram." *Scappiamo.*
Chacharoong: A "big talker" or chatterbox. *Chiacchierone.*
Cheemant: Cement. *Cemento.*
Coosing: Pillow. *Cuscino.*
Duttor: Doctor or physician. *Dottore, medico.*
Faccia loonga: An unhappy person; to have or make a long face. *Essere scontento, faccia lunga.*
Fatifurb: Be smart, or clever, or "wise up." *Fai il furbo.*
Fa poleet: Be clean and tidy; clean up. *Pulisci.*
Fazoling: Handkerchief. *Fazzoletto.*
Fia: Girl. *Ragazza.*
Foorka: Fork. *Forchetta.*
Granda: Grandmother. *Nonna.*
Lazzaroong: Lazy person; lazybones. *Pigrone, lazzarone.*
Magher: Thin or skinny. *Magro.*
Mamaluke: A silly or stupid person. *Stupido, scemo.*
Pasta soocha: Cooked pasta. *Pastasciutta.*
Pasteech: A mess, clutter. *Pasticcio.*
Sara la porta: Close the door. *Chiudi la porta.*
Scoowa: Broom. *Scopa.*
Scoowa mahng: Hand towel. *Asciugamano.*
Sta cheeto: Be quiet. *Sta zitto.*
Strahk: Tired; worn out. *Stanco.*
Teestoong: Stubborn person. *Testa dura* or *testardo.*
Tooca nang: Don't touch anything. *Non toccare.*
Toorta: Tort or cake. *Torta.*
Toos: Cough. *La tosse.*
Va guighe: Go play. *Vai giocare.*
Vaj: Old. *Vecchio.*

North Beach Italian

Bildare: To build. *Costruire.*
Il billo: The bill. *Il conto.*
Bisi: Busy. *Occupato.*
Una bocchesa: A box. *Una scatola.*
Un bucco: A book. *Un libro.*
Il bosso: The boss. *Il padrone.*
Una canna: A can. *Un barattolo.*

I cecchi: The checks, as in bank checks. *Gli assegni.*
Il cotto: A coat. *Un cappotto.*
Il carro. The car. *La macchina.*
Draivare: To drive. *Guidare.*
Duri: Dirty. *Sporco.*
Il floro: The floor. *Il pavimento.*
Frisare: To freeze. *Congelare.*
Il friuei: The freeway. *L'autostrada.*
Una giobba: A job. *Un lavoro, un mestiere.*
Isi: Easy. *Facile.*
Le lame chiappe: Lamb chops. *Costolette d'agnello.*
Un magazzino: A magazine. *Una rivista.*
La marchetta: The market. *Il mercato.*
Una mistecca: A mistake. *Uno sbaglio.*
Noisi: Noisy. *Rumoroso.*
Parcare: To park, as in the car. *Parcheggiare.*
Una suera: A sweater. *Una maglia, un maglione.*
La renta: The rent. *L'affitto.*
Una raida: A ride. *Un passaggio.*
Testare: To taste. *Assaggiare.*
Le tomate: The tomatoes. *I pomodori.*
Toffo: Tough. *Duro, forte.*
Il trobolo: Trouble. *Un disturbo.*
Un trocco: A truck. *Un camion.*

PROVERBS—I PROVERBI

Proverbs were another part of everyday life and language for Italians in Oakland and elsewhere. "*I proverbi*," grandmothers and mothers would caution children—"mind the proverbs." Rooted in Italian folklore and culture, the brief sayings and words of wisdom can be as meaningful today as centuries ago, and they apply in English as well.

Here are some examples of proverbs exchanged within families and among residents of Oakland's Italian American community:

Sbagliando s'impara: Learn from your mistakes.
Amici e vino devono essere vecchi: Wine and friends must be old.
Il riso fa buon sangue: Laughter is good medicine.
Canta che ti passa: Sing and it will pass.
Chi va piano va sano e va lontano: Who goes slowly goes in good health and travels far.
Detto, fatto: What is said is done.
Scopa nuova scopa bene: A new boom sweeps clean.
A tavola non si invecchia mai: At the dinner table you never age.
Troppi cuocchi guastano la cucina: Too many cooks spoil the meal.
Meglio soli che male accompagnati: Better to be alone than in bad company.
Dimmi con chi vai e ti diro chi sei: Tell me who you go with, or who your friends are, and I'll tell
 you who you are.

www.arcadiapublishing.com

Discover books about the town where you grew up, the cities where your friends and families live, the town where your parents met, or even that retirement spot you've been dreaming about. Our Web site provides history lovers with exclusive deals, advanced notification about new titles, e-mail alerts of author events, and much more.

Find Your Place in History.